FOLLY BEACH

FOLLY BEACH

Glimpses of a Vanished Strand

Bill Bryan

Charleston | London

THE
History
PRESS

Published by The History Press
Charleston, SC 29403
www.historypress.net

Cover art: From a painting by Jennifer Smith Rogers. Rogers lives in Mount Pleasant, South Carolina, and exhibits her work at Smith Killian Fine Art in Charleston, South Carolina (www.smithkillian.com).

First published 2005
Second printing 2006
Third printing 2012
Fourth printing 2013

Manufactured in the United States

ISBN 978.1.59629.084.6

Library of Congress Cataloging-in-Publication Data

Bryan, Bill (Bill McIver)
Folly Beach : glimpses of a vanished strand / Bill Bryan.
p. cm.
ISBN 978-1-59629-084-6 (alk. paper)
1. Folly Beach (S.C.)--History--20th century. 2. Folly Beach
(S.C.)--Social life and customs--20th century. 3. Folly Beach
(S.C.)--Buildings, structures, etc. 4. Folly Island (S.C. :
Island)--History--20th century. 5. Folly Island (S.C. : Island)--Social
life and customs--20th century. I. Title.
F279.F63B79 2005
975.7'91--dc22
2005019740

Notice: The information in this book is true and complete to the best of our knowledge. It is offered without guarantee on the part of the author or The History Press. The author and The History Press disclaim all liability in connection with the use of this book.

Dedication page: (Bottom) Dad and me at Folly in 1946. *Author's collection.*
(Top) Me in shades at Folly in 1947. *Author's collection.*

Contents page: In the early years at Folly, cars were permitted on the beach. *Author's collection.*

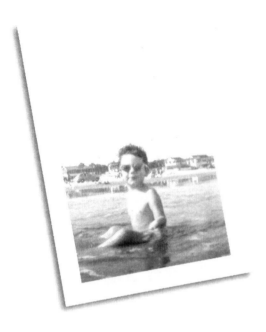

To the memory of my mother, who enjoyed the old Folly.

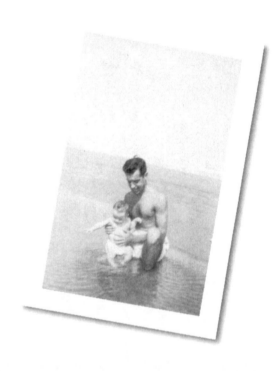

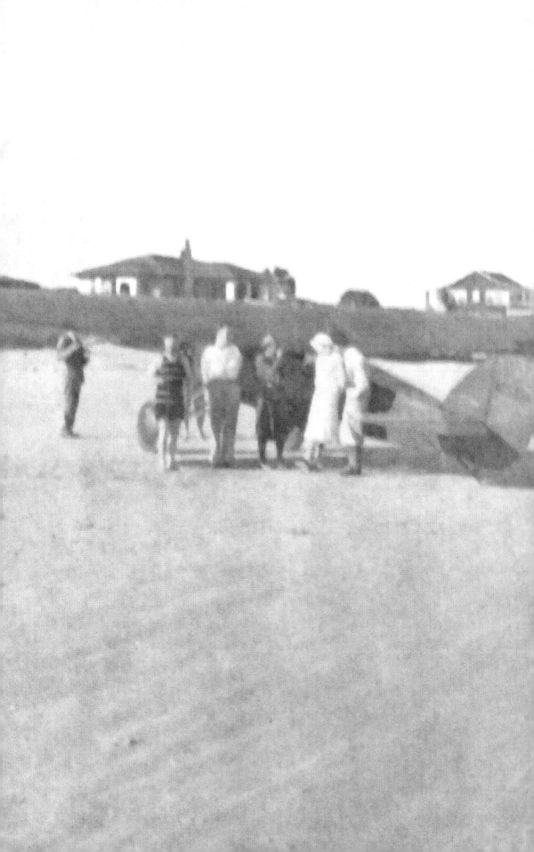

Contents

Introduction

Folly Beach. For many years, to many residents of the Carolinas, the name was synonymous with fun. The whole point of going to the beach was to get away from the daily grind, to let your hair down, to escape city life.

Folly Beach in the 1940s and 1950s was the place to go. As a child, I thought it was the most magical place of all. It ranked right up there with Charleston's Battery and Hampton Park as my favorite hangout.

The earliest pictures show me with my family under a makeshift tent. I was not yet one year old. The year was 1946.

From that point on, I couldn't get enough of the place. (To this day, despite enormous changes, I still get a kick every time I cross the last bridge leading onto Center Street.)

In the eyes of a child, any beach is a delight. Folly was that and more. It is difficult to put into words the enormous hold the place had on children. There wasn't any place around that looked like Folly. Other nearby islands offered innumerable attractions but none had the feel of Folly. That's it! The *feel* of the place. And exactly what did

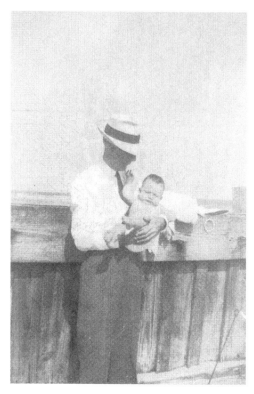

My maternal grandfather and me in 1946. *Author's collection.*

it feel like? To most grownups it probably appeared rundown and past its prime. Its heydays were the preceding two decades. By the end of World War II, to many residents it seemed Folly had seen its best days.

From a child's viewpoint, it was just right.

Who cared if the famous Folly's Pier had lost most of its paint and had become weathered through years of relentless sun, surf and storm? Who cared if the cottages were primitive to a fault with sloping floors, rickety steps and lack of paint? What was more wonderful than to have the tide wash up to the front steps? In some cases, the tide washed right under many of the houses.

Many adults, likewise, took Folly's drawbacks in stride. There was no city water. You had to fill up jugs in town and haul them to the beach. The island's water used for bathing had a sulphur smell and was decidedly disgusting. Most people took full advantage of the ocean to rid themselves of sand, if only to exchange it for the sticky feeling the ocean left.

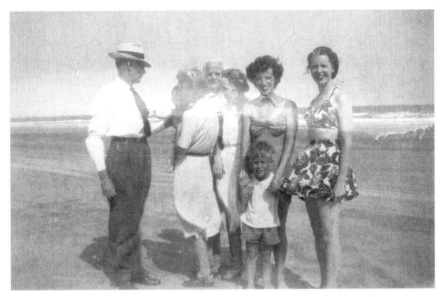

My family at Folly in 1946. *Author's collection.*

Back in the decades of the '40s and '50s, people's ideas of a stay at the beach differed greatly from today. The whole purpose, back then, was to "rough it." No one wanted swimming pools, fancy hotels or gourmet meals. A week's stay in a rented cottage was about as good as it got!

A whole week away from city life! (Most Charlestonians still lived in the cramped city, although the suburbs started booming after World War II.) What child wouldn't love those carefree days, before the dangers of sunshine took away much of childhood fun? We spent the entire day at the beach from the time we finished breakfast until late afternoon, with only occasional breaks for midday dinner or snacks. We were always in and out of the house grabbing something and racing down to the ocean again. Carefree days. Absolutely unlike much of what passes for vacationing today.

One of the reasons to rent a beach cottage back then was an excuse to have a weeklong party, inviting all your friends and relatives. There was no such thing as occupancy limits that I was aware of. People crammed as many guests as they could into the ramshackle abodes.

Vacationers from all over the country would return to Folly's shores year in and year out. The general appeal of the place was

felt far and wide. Forces of nature combined with a general lax building code and even laxer enforcement with a don't-give-a-damn attitude—to produce a what? An odd little community by the sea? A haven for the down and out? A place of romance and fun? All these and more. A place like no other. You had to be a part of Folly in those days to understand the tremendous hold the island exerted.

This book is not for those who belittle the small island that bills itself today as "The Edge of America." Folly suffered economically for many years, especially during the 1970s, and was ridiculed by many local residents.

What then does account for Folly's enduring charm? It can't be her size. It can't be her scenery. Other nearby islands offer superior food. It can't be any number of things. As Southern islands go, Folly may seem rather ordinary. It lacks the unsurpassed old-time flavor of Pawley's or Sullivan's and the cachet of Kiawah and Seabrook. It doesn't have as many shells as Edisto and it isn't as thickly wooded as Hunting Island farther down the coast. It may try to be "Myrtle Beach Lite," but because it is so small, it can't match it. It is an island utterly unto itself, entirely idiosyncratic—peculiar, as Charleston used to be before it became a year-round tourist destination.

Folly was, during the 1940s and 1950s, that rare sort of place one happily stumbles upon and cherishes until one day he finds it no longer exists.

Getting there

Along, winding two-lane highway led from Charleston, across the Ashley River, across the Wappoo Creek and through James Island to Folly Island.

As you crossed the Ashley River Bridge (only one two-way bridge at the time) you passed several old subdivisions before you crossed the Wappoo Bridge, then skirted the Country Club of Charleston and McLeod Plantation. From there you eventually wound your way through thick forests, fields and farms for miles with only a few houses scattered along the way.

Farther down the road, you passed several vegetable stands manned by local black farmers. If you were in the mood for fresh corn, tomatoes, watermelons and other summer delicacies, you pulled over and for a nominal sum stocked up on what you wanted, and then were on your way. Anticipation mounted as you neared the causeway, lined on both sides with palmettos, giving a hint of all the charms of a beach that lay ahead.

Over a few more bridges, crossing creeks and finally, the Folly River. Along the causeway, small islands were scattered here and there breaking the vast panorama of the marsh. As you crossed

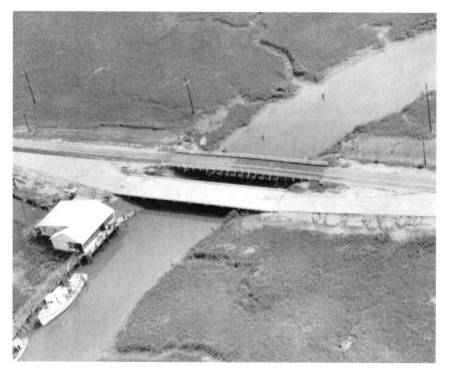

A new bridge replaces an old one. *Courtesy of the* Post and Courier.

the last bridge you were on Center Street, the main drag of the island. The street was several blocks long and ended abruptly—in the Atlantic Ocean! Talk about a grand vista (today this is hidden by a massive hotel).

The trip from town was relatively short but seemed like an eternity to a child. ("Are we there yet?" is timeless.)

The pavilion

At the end of Center Street on the right was a large, open pavilion and bathhouse, useful for day-trippers. For those who were renting cottages, the pavilion was a favorite hangout for all ages. Dogs often wandered around too. At high tide the water crept under the building. But at low tide there was plenty of space to drop your beach towel.

A wooden ramp extended from Center Street onto the beach. At low tide, during the 1940s (and decades before), cars would drive onto the beach and park. Cars lined the beach for several blocks. Many got stuck when the tide came in.

What I recall most about the pavilion was the large painting of a woman under water in a provocative (for the time) swimsuit that graced the side of the building facing Center Street during the 1950s. The building was open-air but dark in spots. If I remember correctly, there was a brass rail near the bar. It was a spacious building and, along with the pier, one of the big attractions. It also had some of the best-looking Greek women working there.

The pavilion sold all the normal beach food—hot dogs, hamburgers, french fries, sodas and beer. In the late 1940s and '50s the beach was crowded all summer long, especially on holidays. About the only relief

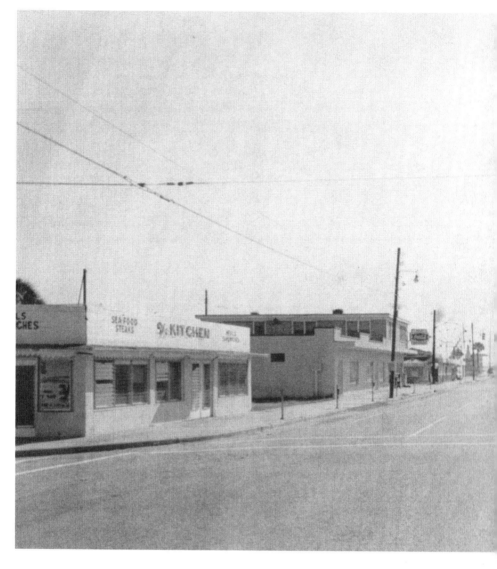

Looking down Center Street in the 1950s. *Courtesy of the* Post and Courier.

from those hot summer days was a trip to the beach. The Fourth of July at Folly was the Lowcountry equivalent of Coney Island: wall-to-wall people; sailors all over the place; not a few drunks staggering around. Wild stuff from a child's viewpoint.

There was always a jukebox playing on the pavilion and, of course there was dancing. But the real place to shake a leg was the pier to

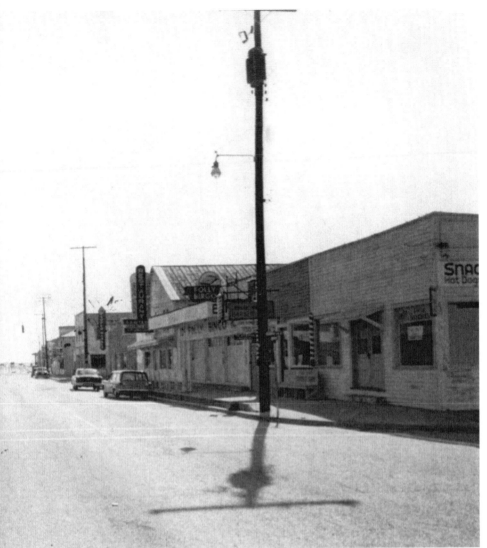

the left of the amusement park, just a skip away down the rickety wooden boardwalk.

It was all very simple and seems odd to the sophisticated beachgoers of today. A few wooden ramps led from the boardwalk to the beach. You had to balance yourself carefully in order to navigate the ramps. The beach in this area always seemed to be wasting away. (And it did practically every winter, only to rebuild somewhat during summer.) Because the beach was in such a flux,

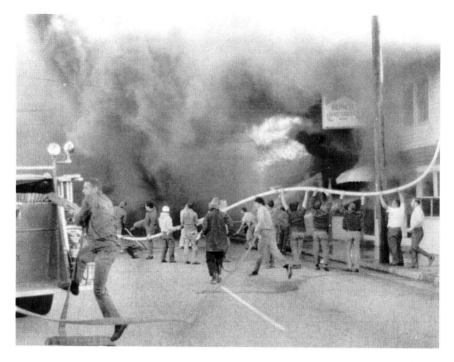

The pavilion and other buildings were destroyed by fire in April 1957. *Courtesy of the* Post and Courier.

the ramps often were raised several feet above the sand and you had to jump down to reach the shore.

Folly was Folly. It didn't try to be Daytona Beach or any more glamorous locale; it was what it was and those who sought a few laughs got just what they wanted. The salt air, all the sights and sounds added up to complete satisfaction.

The pavilion burned in April 1957. Its replacement was built in a matter of months and was much smaller than its predecessor. It was new and bright and clean, but lacked the faded appeal of the old building—and my favorite swimsuit girl was gone.

The pier

Folly's Pier was an institution—the most memorable fixture on the island. It jutted out into the Atlantic at high tide. It was not as elevated as the present fishing pier, but was built a little closer to the ocean. When rough seas came along, the ocean was mesmerizing as the waves came roaring ashore. One of my favorite memories is the sound of the waves under the pier.

The dance floor was enormous. The pier itself was dark. Spanish moss was often draped from the rafters. There was a big stage for the band. Nothing was more romantic than a dance at the pier, especially if there was a full moon. All the big bands played the pier and during the rock era the trend continued. Each decade saw the pier decay bit by bit. When it opened in 1931 it was painted a bright green and white, and "Folly's Pier" was painted in huge letters on the roof. In later years a Coca-Cola sign replaced the original lettering. Gradually other advertisements sprung up. As music became coarser, the pier mirrored the times and gradually deteriorated.

Like the pavilion, the pier went up in a blaze of smoke. But what a run the place had for decades! Before its demise, the pier was the setting of many raucous gatherings. It was the wildest spot on the strand.

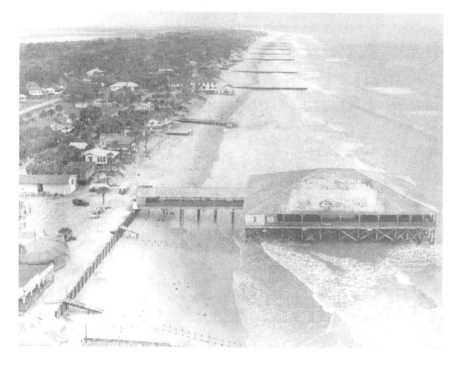

Aerial view shows part of carnival (left), Folly's Pier, groins, cottages and eateries. *Courtesy of the* Post and Courier.

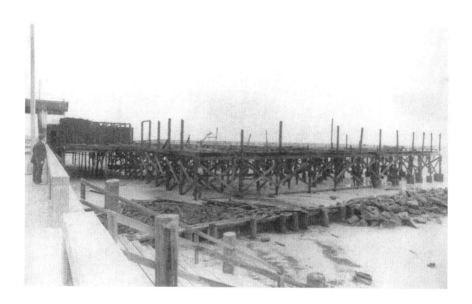

Charred remains of the original Folly pier. *Courtesy of the* Post and Courier.

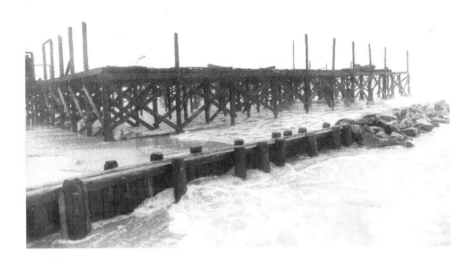

Remains of the pier as the tide rolls in. *Courtesy of the* Post and Courier.

During the late 1950s, many black bands entertained throngs of white beachgoers. At that time, Folly, like all Southern beaches, was segregated. The only blacks allowed on the beach were maids or entertainers or workers.

If 1955 is recognized as the beginning of the rock era, Folly's Pier was in the thick of its evolution. Many top performers of the day played the pier, as did the best performers of previous decades. How could little Folly Beach be such a magnet for these famous groups? Among the entertainers were Tommy and Jimmy Dorsey, Benny Goodman, Count Basie, The Ink Spots and Dinah Shore. Even Hank Williams performed there. Folly in the 1940s was the biggest draw by far on the Carolina coast. Myrtle Beach, back then, was just starting out. Folly had a national reputation in musical circles.

I especially recall one summer afternoon when the pier was mostly empty. I spied a lovely woman wearing gold high heels walking alone along the dance floor. That impression has stayed with me all these years.

As styles in clothes changed from decade to decade, dances at the pier underwent a transformation as well. In the 1940s men wore coats and ties and ladies were clad in evening gowns for the formal dances.

Flames Destroy Folly Pier

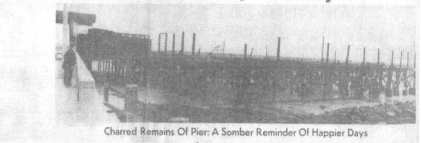

Charred Remains Of Pier: A Somber Reminder Of Happier Days

Headlines from January 10, 1977, tell the story—arson was suspected. *Courtesy of the* Post and Courier.

By the 1950s, all that had changed. Men donned the "hood look" of t-shirts and tight pants. The women wore wide skirts and ponytails.

As rock mania took hold, naturally the dances changed too. But the shag was still the dance of choice, as it had been during the 1940s. Shagging at the beach supposedly had its genesis somewhere along the Grand Strand, probably Ocean Drive. But Folly was a shagger's haven. Just like the pavilion at Pawley's Island, the pier at Folly was *the* spot to strut your stuff. Of all the colorful dance halls along the coast, Folly's Pier clearly stood out. It had an atmosphere that was hard to beat. What young couple wouldn't succumb to the unbeatable combination of sea, sand and suds? (Even if the beer served on tap was Pabst—to my taste the most horrible of all the brews.)

As attire descended from the era of formal clothes to t-shirts, then tank tops and then bare chests, musical trends went from the sweet melodies of Guy Lombardo to the debauchery of the Hot Nuts and everything in between.

A little carnival by the sea

Between the pavilion and the pier stood a small amusement park, about a block long. It had a sign that read: "Welcome to Folly's Playground."

Crammed into this space was a merry-go-round, a Ferris wheel, swings, a popular ride called the Whip and perhaps another ride or two. There was a small wooden refreshment stand that sold standard beach fare, especially ice cream cones and sodas. There was also a place that sold snowballs and cotton candy. That was about it.

To a child, though, it was magic. From high atop the Ferris wheel, the beach spread out before you. What a view! A wooden boardwalk connected Center Street to the pier in front of the amusement park, just a spot of sand wedged between the street and the Atlantic Ocean.

Most of Folly's major attractions were jammed along Center Street and adjoining streets for several blocks. A bowling alley was across the street from the carnival. Center Street was lined with eateries and bars, but the carnival was *the* spot for children of all ages. It set up every year at the beginning of the beach season and was pulled

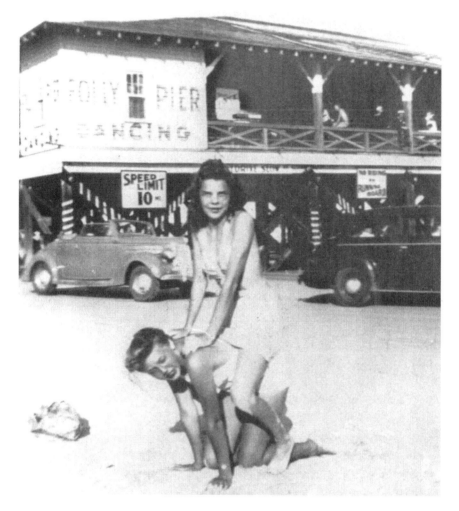

Having fun at the beach with the pier in the background. *Courtesy of the* Post and Courier.

down after Labor Day. Every kid on the beach waited with great anticipation for the carnival to open.

Folly offered something for every taste, from little children seeking thrills to old folks who just wanted to eat an ice cream cone at the pavilion and gaze at the ocean and reminisce about the "good old days" when they were young and probably wild and enjoyed the Folly Beach of the 1920s, when everything was brand new.

To me, though, as I now near the senior citizen age, I think that the 1940s and 1950s were the golden years of youth. Everything was getting frayed during those decades at the beach, but to a young boy it was tops.

Children today would scoff at the little carnival. It couldn't possibly rival all the glittering attractions like Disney World or even Myrtle Beach. I'm not at all certain that the present generation of adults would look kindly on the little carnival either. But back then it was one of the high points of a trip to the beach. As soon as I crossed over Folly River and saw the top of the Ferris wheel above the neighboring buildings, I could hardly contain my excitement.

Just a few blocks ahead lay a carnival, a pier, a pavilion, a bowling alley, places to eat and swim. What boy could ask for more? The Atlantic Ocean itself would have been enough. But a feast lay ahead. A child could spend hours going up and down Center Street from the beach to the bridge. Or he could stay at the carnival and fill up on all the junk food and then head for the beach and spend several more hours until he tired and headed home.

Back then children could wander all over the beach without parental supervision. Crime was virtually nonexistent. A child's day was not rigidly planned like today. You woke up and did whatever happened to strike your fancy. If you were at a nearby rented cottage, you could wander off in any direction and waste an entire day without having to listen to a parent. Children made their own fun. Children met others at the beach and wandered off, playing like pirates and looking for buried treasure. And buried treasure was certain to be hidden somewhere under all the jungle-like growth.

Other hot spots

To the left and right of Center Street for several blocks stretched an array of beachside cottages, a hotel, eateries and rustic bars. Many seaside bars staggered from the pier. Their names changed over the years, but they all dispensed beer in copious quantities. A drunk could stumble from one spot to the next, all within earshot of the music coming from the pier. A poor man's paradise.

At one time the nearest bar to the pier was the Seaside Grill. I forget what it was called in the 1940s. It was one of the wilder spots with outdoor decks and pool tables inside—typical of many beach dives. It had the most colorful clientele of all the bars.

Farther along was the Sand Dunes (nothing very original about any of the beachside bar names). It also had a spacious deck right on the beach. Nearby, jutting out onto the shore, was a small place that sold ice cream cones. I think it was called Weir's. It was elevated and you climbed steps to enter. At high tide the ocean crept beneath the small building.

Center Street splits the island in two. To the left, the beach is called the east side—to the right, the west side. Islanders have favorites. Both sides have distinct personalities, but together form the island known today as funky or unconventional. Folly was that.

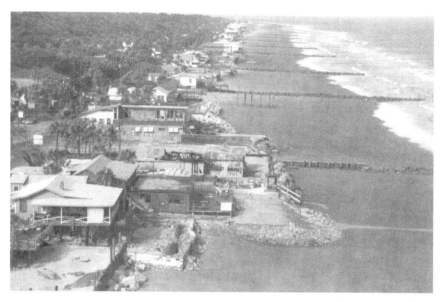

Photo taken in the 1980s shows Seaside Grill and other structures. Note the extensive erosion already affecting Folly. *Author's collection.*

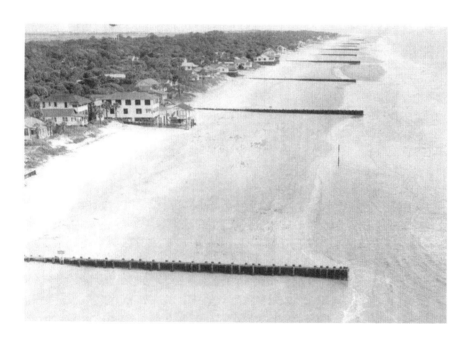

Aerial view shows Weir's snack bar and groins at low tide before erosion took its toll. *Courtesy of the* Post and Courier.

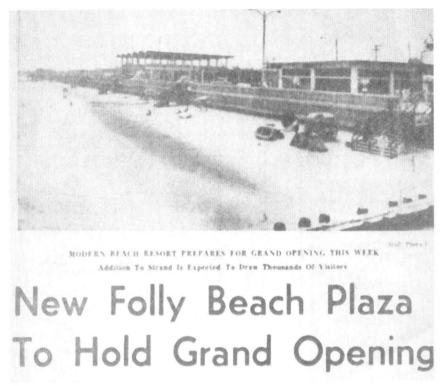

MODERN BEACH RESORT PREPARES FOR GRAND OPENING THIS WEEK

Addition To Strand Is Expected To Draw Thousands Of Visitors

New Folly Beach Plaza
To Hold Grand Opening

The Ocean Plaza opened in 1960. It enjoyed several successful years. *Author's collection.*

Perhaps the buildings on the west side had a more tropical appeal, due in part to extensive erosion that caused palmettos to sit in the ocean at abnormally high tides. The wooden hotel next to the pavilion (the Ocean Front Hotel) sat behind a wooden barricade that kept the ocean at bay. I never went inside the joint. It was one of a few lodgings on the island dubbed hotels. They were hotels in name only. There were also several tiny cottages, often little more than a room or two, to rent. These clusters of huts are mostly gone, but one such complex still exists just west of Center Street, between West Ashley and West Cooper Avenues. It has withstood attempts at modernization and assaults from countless storms. It remains one of the few landmarks from an earlier era. Years ago (like most houses on the beach) the cottages were painted white. Today they are green.

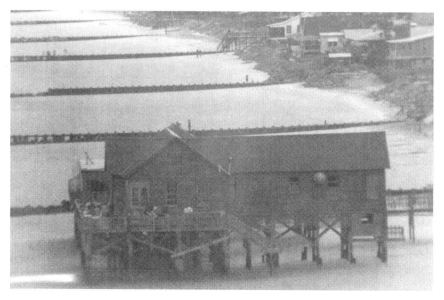

The Atlantic House was a popular restaurant destroyed by Hugo in 1989. *Author's collection.*

Next to the Ocean Front Hotel was an area known as Rainbow Corner. It was a cluster of colorful buildings nestled in a grove of palmettos right on the ocean. There was an area for dancing and drinking. It was one of the most popular spots on the front beach, just a hop and a skip from all the other beachside attractions. Because of its location in a grove of trees it was perhaps the most tropical and delightful of all the haunts.

In September 1959, Hurricane Gracie battered Rainbow Corner and the entire complex was demolished to make way for the massive and ambitious Ocean Plaza development of 1960. The old ramshackle hotel also bit the dust as part of the blocks-long development that radically changed the look and flavor of Folly. More than any other project, Ocean Plaza produced the most profound changes for the beachfront. It essentially served as the end of what I call "old Folly."

The era really ended with Gracie's blow. The beach never was the same after that. The small wooden boardwalk was replaced with a concrete revetment that stretched from the refurbished pier for blocks to where Rainbow Corner stood. It erased the ramshackle flavor of the old days.

Two structures that escaped the developer's eye were two old, abandoned beach houses a short distance from the former Rainbow Corner. During the 1950s they were abandoned beach houses and in the 1970s were joined to create what came to be called the Atlantic House and OTO (Over the Ocean) Bar.

When they were built in the 1920s, I understand they faced a broad beach with dunes. The larger of the structures was built of cypress and had pilings sunk deep into the sand. The hurricane of 1940 did extensive damage to these two grand dames. But they withstood Gracie in 1959 and David in 1979, only to be destroyed ten years later by Hugo.

There were a number of old beach houses in this area, many dating to the '20s and '30s. A few remain. Many more are routinely knocked down, replaced by more expansive structures. Today, these new "McMansions" seem to be popping up at beaches up and down the coast to serve the needs of present-day beach dwellers who care little for the feel of the past. To me, this is one of the saddest stories of all. Modern-day height elevation and zoning are rapidly changing the flavor of beaches everywhere.

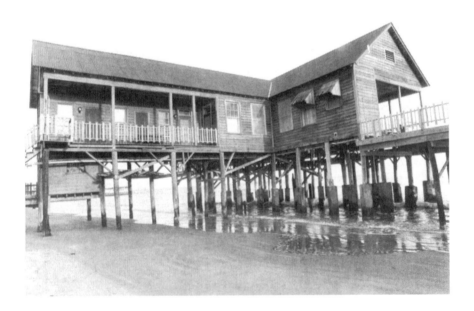

Old beach cottage before it was renovated to become the Atlantic House. *Courtesy of the* Post and Courier.

But back in the 1950s the Atlantic House was just a relic, a ghost-like structure that was over the ocean at high tide. Years of salt spray and sea had weathered the structure to a silvery grey. It was a favorite place for children to explore. You climbed up the steps and wandered at will through the large rooms. Because the house was elevated higher than its neighbors it offered some of the best views of the West Side of Folly. Many beachgoers sought relief from the sun by spreading their towels in the cool shade beneath the old house.

The 1940 hurricane wiped out a row of houses west of the Atlantic House that stretched many blocks. Perhaps one of the most famous of these smaller beach cottages was the one rented by George Gershwin in the summer of 1934. The humble house served as his headquarters as he and Charleston author DuBose Heyward collaborated on the opera *Porgy and Bess*. After the hurricane smashed these houses, remains stayed on the beach for most of the 1940s. A picture of me taken in 1946 shows remains of revetments at low tide. It's typical of Folly's laidback attitude that these remnants cluttered the beach with apparently no attempt to remove them. (You could picture the uproar today from residents of the beach if any remnant of hurricane damage remained stuck in the sand.)

A little beyond these vanished houses stands one of the most appealing cottages on the beach. It was originally on the second row, but now faces the ocean. It's painted a dull blue-green and sits amid a stand of palmettos. It is next to a parking area and walkover. It's a popular subject with local artists and is fairly representative of what many houses on the island looked like in decades past. What is now the parking area was just a narrow lane that led to the beach. There were no walkovers to lead you over the dunes in those days. Drivers along East and West Ashley Avenues could catch glimpses of the ocean from these little lanes between the dunes. But now the views are blocked by the walkovers, which were built to protect the dunes from trampling feet. Today all walkovers carry signs telling visitors when dogs are allowed on the beach, what dangers lurk on the beach (strong waves and currents) and other admonishments. Such is progress.

Some personalities

Charleston has had her share of prominent authors, artists and historians. Many of them had ties to Folly.

DuBose Heyward, perhaps Charleston's most famous author of the twentieth century, had a summer home on West Ashley Avenue. He called it Follywood. It's still there, hidden behind a high fence a recent owner put up. When Heyward built his house in the 1930s it was surrounded by trees and had good views of the ocean and shifting dunes. It still does, but many more houses have been built since that time. When Gershwin stayed at Folly, he often was entertained by Heyward and his family. The house remains today a sort of shrine to devotees of jazz and Gershwin and those who hold strong attractions to that era.

Elizabeth O'Neill Verner was one of Charleston's finest artists. She often painted at Folly, as did other artists of her day. The nationally prominent Edward Hopper also painted at Folly. An artist cousin of Gershwin's joined him on his visit and painted local scenes. There were countless others, including my dear friend, the late Sally Aimar, who summered at Folly for half a century.

Sally, along with her pharmacist husband Harold, was one of the most colorful and delightful of Folly's residents. She painted daily,

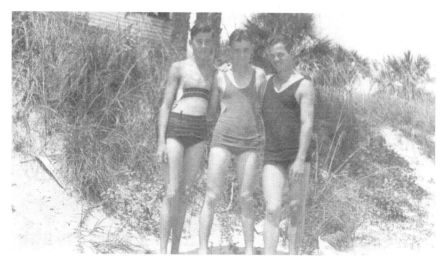

Old photo shows bathing attire in decades past. I found this photo at a flea market. *Author's collection.*

often sitting on her tiny screened front porch high on a bluff. The house was on East Indian Avenue, practically in the marsh. Abnormally high tides sometimes brought water from the Folly River right up to a room under the house where she often stored her paintings.

Sally not only enjoyed watercolors, she also took part in every facet of Folly life. She knew everyone on the island. She was a repository of facts and folklore. Harold knew all about the flora and fauna of the island. He had a few tall tales to tell. Together they were a part of Folly that slowly has slipped away. Most of the old-timers are gone now and with them a treasure trove of memories.

Samuel Gaillard Stoney, Charleston's famous historian and a colorful character in his own right, had a summer home at Folly. Where it was located I've never been able to find out. Some say it was near Heyward's house. Stoney enjoyed swimming in Folly's surf and soaking up island life.

Folly always has had a bohemian air, attracting those who advocated a laid-back lifestyle. Sullivan's Island was too strait-laced for these carefree souls. Folly's freewheeling ways attracted legions—it was a bastion for the nonconformists and remains so to this day.

Folly was also home to a somewhat cosmopolitan mixture. The Greek community exerted a strong influence. They ran many of the

most prominent attractions on the island and invested heavily in real estate over the years. There was also a smattering of Jews, including the beloved lifeguard Jack Nathan, who strutted his physique near the pavilion. There were many Roman Catholics who built a charming church on Center Street. Folly was also home to many retired folks who came from all over the country. There were even a few foreigners who somehow found their way to Folly's shores.

Gershwin's impression of Folly summed up much of the appeal of the strand. He said it reminded him of a battered South Sea Island. Much of the primitive nature of the island, so beloved and enjoyed, has sadly worn away and been replaced with rampant development.

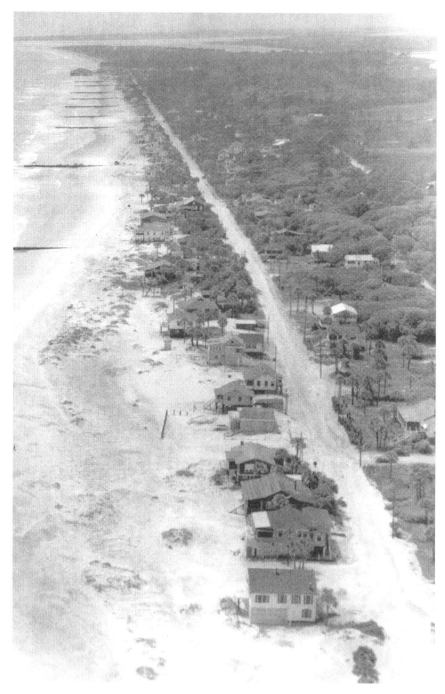

Aerial view shows east end of island with old cottages amid dunes and trees. Circa early 1950s. *Courtesy of the* Post and Courier.

Street names

Visitors to Folly must scratch their heads when they look for certain addresses. Houses on the same street may have entirely different street names. My little cottage was on East Hudson. The house directly across the street was on East Erie.

When the island was developed, the plan was for one house per lot, with all homes facing south toward the ocean. Over the years, lots frequently were subdivided, allowing two (or more) houses on one lot. Therefore there was often confusion as to what street the house was on. Many houses across the street from my former cottage faced Hudson Street but some faced East Erie. Go figure.

Some of the street names themselves seem odd to outsiders. Many of the street names have obvious local associations—Ashley and Cooper—and Atlantic Street is self-explanatory. But where did Arctic, Erie, Huron, Hudson and Michigan come from? If you guessed the Great Lakes, go to the head of the class. But why? Just another Folly peculiarity I suppose. And Indian? Well, Indians did live on the island centuries ago, so I guess that makes some sense.

Let's eat!

Who doesn't get hungry at the beach? It must have something to do with the salt air. Who knows? Every time I go to the beach I crave seafood, which is logical. But I also often want crackers and chips and anything else you'd have at a picnic.

In the glory days, Folly fulfilled your hunger. Everywhere you looked there were places that sold food. If you rented a cottage, you probably stocked up before you left town. But if you forgot anything, there was always a little corner store on Center Street or nearby.

As a child I enjoyed stopping in one of those small markets to get a popsicle or gum or soft drink or ice cream or candy or crackers or chips or jawbreakers or anything else a young boy desired. These little stores did a brisk summer business and relied on the few permanent residents during the winter.

After spending hours in the surf, any kid gets hungry. I'd race into the house and fill up on Cheeze-Its and peanut butter. I practically lived on peanut butter for most of my youth. And chocolate milk. And corn on the cob. And okra gumbo and butter beans and squash and fried chicken and baked ham. Boy, did I like to eat! But so did everyone else, and most people cooked all this stuff along with fresh

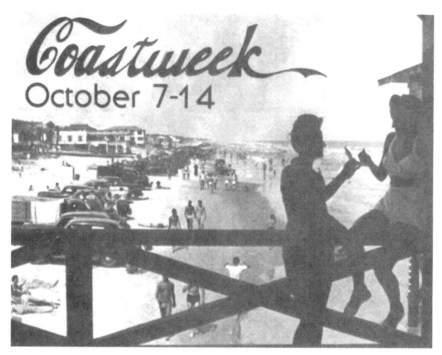

Ladies quenching their thirst on the pier. This photo, taken in 1946 by Ronald Reilly, was on a brochure for "Coast week" in 1984. *Author's collection.*

seafood and, of course, red rice. What Charlestonian would do without rice?

And that was just what you ate at home. The men partook freely of beer and liquor. Boy, could some of those World War II vets drink! And drink they did—practically all the time. Beer cans were stacked outside many a cottage, forming island pyramids. If the men didn't get enough suds at home, there were watering holes in the center of town.

Besides the many bars (including the Riptide, with its loyal following), Center Street had a few eateries to boot. But the favorite spot to get a good seafood dinner was not on the beach itself but just across the river—Andre's. It had atmosphere in spades. It was a nondescript frame building that sat a few yards from the bank of the Folly River. A little creek was on the other side and marsh beyond that; the perfect setting for seafood. The large eatery had worn wooden floors, booths and two colorful murals of shrimp boats and other Lowcountry scenes. Probably fish nets, too!

The service was good and so was the food, mostly fried like most everything in those halcyon days before the national obsession with cholesterol. What can beat fried shrimp and cold beer? Fried oysters and hush puppies and french fries and coleslaw also were on the menu. Oh how I miss this place! Andre's was later called Sam's, then Bushey's, all serving memorable meals until recent years. Hugo did extensive damage to the building and it was rebuilt with even more nautical flavor.

It has since been replaced with a condominium complex. (Everywhere I look today I see condos. Where once little restaurants stood, condos pop up like weeds.)

Another favorite seafood place was the Sandbar, surrounded today by houses. Back then the Sandbar was isolated down a little sandy road that led from West Indian. It sat perched among live oaks, across the river from Andre's and docks with shrimp boats. Its setting was stellar. Geese often wandered around the grounds near the water. And the food! In addition to all the standard fried dishes, the Sandbar offered my favorite, Seafood a la Kiawah. It was a savory, buttery baked casserole full of oysters, shrimp and scallops. Delectable! The Sandbar probably was the finest seafood restaurant around, ranking just next to the incomparable Henry's on Market Street in Charleston. The Sandbar is now called the River Café and is located on Sandbar Lane.

Charleston in those years was not the culinary destination it is today. The city had but a few first-class restaurants. Most Charlestonians ate at home, filling up on classic Charleston dishes prepared by black cooks. Almost everyone had a cook in those days. Many worked every day and often even arrived in time to cook breakfast of hominy and little creek shrimp—the best!

Aside from Henry's, many Charlestonians ate lunch at Robertson's Cafeteria, in those days located downtown on Broad Street near East Bay. My grandfather, a banker, ate there Monday through Friday. They served all the dishes Charlestonians liked—nothing fancy, but good, honest food. It was probably one of the most beloved cafeterias in the country.

But I digress. To get back to the beach and all its eateries, one can never leave out the most amazing place of all—Bowen's Island. You had to see the place to believe it. It's still there today, thank goodness— one of the few remaining holdouts.

The restaurant sits at the end of a road leading off Folly Road through a causeway in the marsh and through a thick jungle-like growth. Up until recent times, the road was dirt and full of ruts (it is now paved). Often at abnormally high tides, the road nearest the restaurant was partially under water. What a trip! It was especially daunting in a summer thunderstorm when torrential rain and darkness made driving nearly impossible. I recall one such night when my dinner companions were the aforementioned Sally and Harold Aimar. Sally shrieked and yelled (as she was wont to do) as I drove the rutted road to the restaurant.

Once there, the visitor was in for a big surprise. The restaurant consisted of a cinderblock hut with a screen door and small porch. You entered a dark room whose walls were covered with writings from customers. There were several booths and mismatched tables and chairs. Several television sets were stacked one upon the other. There was an ancient jukebox that sometimes worked. When it did, the selection included many hits from the 1940s including my favorite, "Green Eyes."

Then there was Miss May Bowen, who greeted customers. You placed your order right in the kitchen where all the food was cooking. There was a cooler of beer and soft drinks. You made your choices, went to your table and drank and waited for your order to be cooked and delivered by Miss May. You drank and laughed and drank some more and often waited and waited and waited. The place could get extremely busy on a weekend night all year long and the cooks took their time processing orders. What was the hurry?

While you waited, you could pass the time reading notebooks stacked on a table near the jukebox. The notebooks contained odes to the eatery. Very entertaining. If you tired of that, there were the newspaper write-ups on the wall, describing the joint in often picturesque prose. Many of these articles were full-page spreads with color pictures. This local gem was even featured on the Huntley-Brinkley news hour one time.

Quite a bit of notoriety for such a humble place. But that was just the point. It was such an institution and so famous that people came from all over the country. It wasn't so much the food, though it served good fried seafood. And the roasted oysters in winter were the best. But it was more than that. It was the atmosphere of the place—totally unlike anything else around here.

The setting was superb, except if it was a still, sweltering summer night full of mosquitoes. Naturally, the restaurant inside was hot; massive tall fans provided the only breath of air. Mr. Bowen also contributed to the flavor as he wandered around the joint greeting happy customers. Sometimes he tired of all the hoopla and went over to look at one of the televisions, oblivious to all the goings-on. It is still a popular eatery and remains as casual as it was in years past, despite recent upgrades.

There was another restaurant on Peas Island across Folly Road from Bowen's Island. In later years it was Delorce's, but back in the '40s I never saw the place. But I understand it served good food, too. Geezer's was another popular and colorful drinking hole farther down the road.

No, you never went hungry or thirsty at Folly!

Cottages, shacks, huts and more

As I mentioned earlier, Folly was a primitive place, full of ramshackle houses. Here and there were attractive spacious houses. Then there were the peculiar structures that would stand out in most any locale but blended in to the overall Folly scene. There were a few converted trolley cars that had been brought over to the island in the early days. At least one still exists on East Hudson, hidden among the trees. There were a few log cabins, too. Many of the cottages were for weekend use only. Many more were substantial enough for summer seasons. A few were built for year-round use.

It was the humble huts and shacks that more than anything contributed to the charm of the island. Most were hidden among the undergrowth. Many were stained green and blended into the woods. Most had screened porches, however small, to take advantage of the afternoon sea breezes that swept the island from April until September.

Most of my associations with Folly were the cottages friends and relatives would rent. I had friends who lived year-round on the island and their houses were substantial. But it's the rental units that bring back the most recollections and a few laughs.

One such place was the Seascape Apartments that practically sat in West Ashley Avenue, a block away from the Atlantic House. It was a rambling structure whose front yard extended into the Atlantic at high tide. It was painted white back then. Now it's a bright blue. It has been remodeled and bears little resemblance to the old place. But what fun I had there with friends! The beach in front was littered with tree stumps, making swimming hazardous at high tide. Renourishment has added a broad shore today.

Another old-fashioned beach house nearby was probably my first taste of Folly when I was an infant. Friends of the family owned the house and lived there all year. It was spacious with a broad porch that faced the ocean. Talk about charm! I recently learned that the house was originally located closer to the ocean, but was moved farther back after a hurricane, probably the 1940 storm. Thank goodness it hasn't gone, unlike its neighbor, a picturesque pink 1920s cottage, torn down and replaced by a gigantic, towering house.

Many of the other houses I recall were newly built structures down the east end near the Washout and beyond, heading toward the coast guard base.

One of my favorites was located where the Washout is today and was destroyed by Hugo. It was a simple building with a large screen porch and steep steps that led to the beach. Beneath the house was a shower with its evil smelling water. Inside, the rooms were paneled in knotty pine, quite popular in the 1940s and 1950s. It was owned by the couple who lived next door. They lived year-round at the beach.

Farther down the beach was another similarly styled house that had a beautiful stretch of beach with sand dunes in front. It's gone now, too. And the beach in that area is forever changing.

One of the most interesting houses in the area was located down a long causeway across from the Washout. It was called the Fort and sat on the banks of a creek with many oyster beds. Back then it was painted pink. The house (really two houses next to each other and moved to that spot) is now painted a more subdued grey.

Surveyor Lucas Gaillard and his family had a large stucco house on the front beach. It has recently been torn down. Gaillard, brother of former Charleston Mayor J. Palmer Gaillard Jr. and a cousin of mine, surveyed nearby Tabby Island. The little area is now one of the most delightful sections of the beach. In the same general area were many colorful old houses that dated back to the early years of the

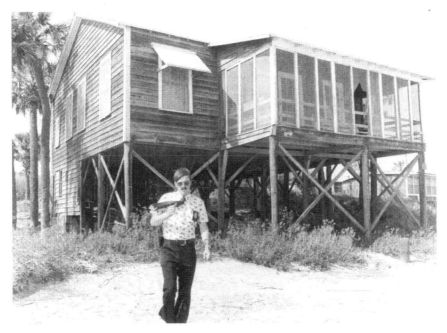

This house on the east side was destroyed by Hurricane Hugo in 1989. *Courtesy of the* Post and Courier.

area's development. One in particular was an old-fashioned place on the ocean, smashed by Hugo and rebuilt. Next door for many years stood a simple little hut, little more than one-room large, undoubtedly used for one day use only.

Many people built these little places just to have a place to change clothes and enjoy a day at the beach. They were scattered all over the island. Many were enlarged over the years and grew haphazardly, but contributed more than anything to Folly's peculiar appeal. A few exist today, but they are becoming scarce and Folly is the poorer for their loss.

The Washout

Back then, the area now known as the Washout was an isolated, lonely stretch of shoreline, relatively unknown to many folks who went to Folly for the day. Most vacationers stuck to the main section of town, to be close to all the popular attractions.

But the Washout was known to birders, fishermen, lovers and those who sought solitude. It was a popular spot to catch crabs.

At one time the area was an inlet, separating Folly Island from the area to the east, called Little Folly Island during Civil War years. The area gradually filled in until it was just a sliver of land separating the ocean from the vast marshland and all the little creeks that meandered through it.

Now one of the prime surfing spots on the East Coast, the Washout in my youth was just a remote strip of sand. There were no surfers until the 1960s. Back when I was a kid, everyone grabbed an inner-tube tire to float on in the ocean. Body surfing also was enjoyed. Now the area is one of the most congested places around, jammed on summer weekends with cars and surfers and girls who come to gawk. A far cry from those days of yesteryear when you could walk for miles and miles and rarely see a soul.

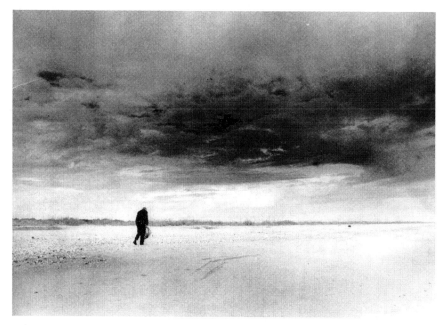

A beachcomber enjoys this lonely stretch of beach. *Courtesy of the* Post and Courier.

The Washout was gradually discovered by more and more vacationers and houses continue to spring up along the stretch all the way to the coast guard base and the far tip of the beach. When I was young, sand dunes stretched for miles and miles. Groins had not yet been placed on that part of the beach. Walking along the wild and windy stretch, I often stumbled upon interesting pieces of driftwood. I still have one such piece today that I collected and dragged back to the car. When I sawed off a long strip, what remained looked like the head of a cow. It's still quite a conversation piece. For years it was propped on top of a bookshelf next to my bed. I also found driftwood that looked like sharks and other fish that I mounted on my bedroom wall. (I had a vivid imagination and could think of all sorts of mysterious tales just looking at the driftwood.) Naturally, I'd also drag back home other stuff found along the beach including odd marine life and unusual shells.

From the Washout to the coast guard base, the beach stretched on and on. Each year, more houses cropped up among the sea oats. But

the stretch still remained remote and unspoiled. There weren't many trees on this little sliver of sand and the winds were forever shifting the dunes from day to day. You never knew from one visit to the next what the beach would look like. One year it could be broad and flat and extend out into the sea for miles. It could all vanish by the time you returned a year later.

It would have been interesting to monitor all the changes of the sand from week to week. Erosion has afflicted this strip of beach for countless years, due largely to the ill effects of the Charleston jetties built in the late 1800s.

The Washout was one of the best spots to steal a kiss, away from crowds and prying eyes. It's getting harder and harder to find a place to escape these days as Folly becomes more popular, and about the only remote places left are found in the dead of winter or a rainy Sunday afternoon.

As you drive down East Ashley and come to a curve in the road, the Washout begins. Even today it is as if you've entered another beach. Gone is the thick canopy of trees. Intense sunlight floods the area. The brightness and wild beauty and remoteness of the spot was its attraction then just as it is now—getting away from it all. You were in a different world, miles away from noisy, congested Charleston.

The coast guard base and lighthouse

At the very tip of the eastern end of the island, separated by Lighthouse Inlet from Morris Island, was the coast guard base, still functioning in the 1940s and '50s. It is now abandoned and will one day become a park of sorts, if it doesn't wash away first. Erosion over the past several years has been fierce in this area, as shifting sands work their way eastward out into the inlet toward the lighthouse.

Back then the lighthouse was still active. What a thrill for a child to see shafts of light coming from a lighthouse in the middle of the water, illuminating remote stretches of beach. When the lighthouse was built on Morris Island in the late 1800s, it sat a good distance from the ocean. Over the decades, the beach eroded and the lighthouse was stranded in the inlet. A new lighthouse was constructed in 1962 on Sullivan's Island and the Morris Island Lighthouse went dark. But it still exerts a strong romantic pull to all those who see it from the far end of the beach. The area is a favorite spot for artists, photographers and lighthouse fanatics.

Pictures from as recently as the early 1940s showed the lighthouse still barely attached to the land of Morris Island, although waves lapped at its base. Over the next decades it grew farther and farther

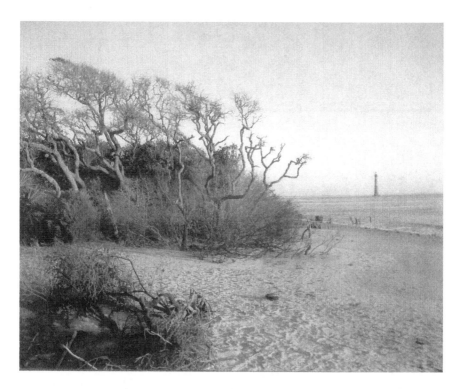

Maritime forest meets beach at east end of island. This is the site of the former coast guard base. Morris Island Lighthouse can be seen in the background. *Photo by Joseph C. Wilson, www.mudseye.com.*

away from shore as the land around it eroded. Morris Island itself is little more than a large sandbar today, a far cry from its broad beaches during Civil War days.

It's foolish to think that the beach you walk on today will exist five, ten, twenty years from now. The islands are constantly shifting. Hurricanes and winter storms accelerate the problem. The coast guard base today is a case in point. Decades ago the area had a wide, level beach. Back in the 1960s it gradually retreated. Extensive groins and rock revetments were constructed and over the next decades the beach grew wider and wider. Several years ago, though, all that changed and the area is in sad shape again. The area that faces the lighthouse and contains what remains of the maritime forest is rapidly eroding. Each time I walk that stretch at low tide I wonder how much longer it will last. Fifty years ago it was an entirely different beach.

Just five years ago it was a different place. This area is probably the best spot for students of beach geology. What lessons you can learn! The coast guard base has long been the favorite spot of ornithologists who witness bird migrations and try to spot that rare bird that may show up.

Folly has areas of incredible beauty, tucked away amidst the encroaching tawdriness. It may take you several visits to find these hidden spots, but the search is worth it. Most beachgoers of years past and even today dash to the beach as fast as they can and drop a towel as close to Center Street as they can get. They want to be near the thick of things. They want to be where things are hopping, where all the girls are and where a brew is close at hand. But for those who want to escape, just travel a few blocks and you'll get some relief.

But for those who seek even greater solitude, the coast guard base is one such spot. All of the base housing is long gone, but a few steps that lead to nowhere remain. Parts of the base are exceedingly lonely, even depressing. But hidden in the growth is a small pond and little thickets abound. Views of the lighthouse are unsurpassed. It seems like the end of the world as you walk along this lonely stretch.

As you walk around the area, you end up in the marsh and near all the many little creeks that tread through. You look in the distance and see nearby Long Island and beyond that James Island. The area has a timeless appeal. You hope it never changes—that houses don't crop up in unwanted areas to spoil the vistas. The massive new Cooper River bridge can be seen far off in the distance, as can Sullivan's Island and its lighthouse and giant freighters heading out to sea from Charleston Harbor.

No matter how far away from civilization you seem to be, glimpses of modernity creep in. You can't escape. But fifty years ago you could get away from it all with a little less effort. There were fewer houses and fewer people and more wide, open spaces, more fields and farms and forests.

As seasons change and the beach comes and goes you appreciate the natural rhythm of life. Yes, things change. Fashion changes. Times change. But the sea is timeless. In all its many moods it still pulls people toward her. Let's hope one hundred years from now there still will be a beach to walk on.

The Seabrook property

An area a few blocks west of Center Street and on the river side of the island is now a new housing development. Years ago it was a private retreat for Edward Seabrook, whose family developed the beach in the 1920s and owned lots all over the island. This area contains the oldest houses on the island going back at least to the Civil War, if not before. The Seabrook family still owns the far end of the new development. It's strictly off limits to residents.

Decades ago the entire tract was private—a huge forest a few blocks from the busiest part of the beach. Few beachgoers knew the place existed at all. But for those fortunate enough to get a glimpse, it was the most beautiful tract of land on the island. Trees were everywhere—massive oaks, towering pines, palmettos, wax myrtles, bay laurel and cedars, a maritime forest virtually untouched.

A narrow dirt lane led from West Hudson Street onto the property. The lane went on for a mile or so through thick woods until it passed a massive live oak and clearing where the old simple frame houses clustered, right on the edge of the Folly River.

The entire property was a boyhood paradise. You could be Tarzan or Robin Hood or a pirate as you wandered through the forest. Hours

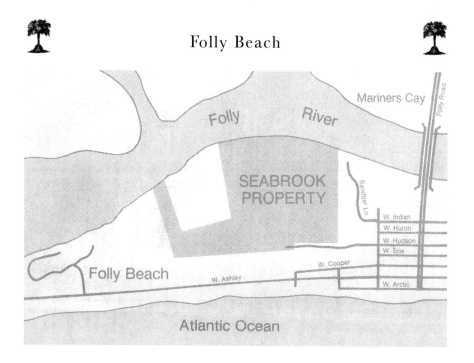

This map from the Business Review section of the *News and Courier / Evening Post* in 1984 shows an area of Folly slated for development. *Author's collection.*

could be spent playing here. And it was just a short walk to the center of town and a bit longer trek to the ocean. Of course, it was off limits to all but Seabrook's friends and family. But many a Folly resident dreamed of the incomparable settings.

Many times I've walked the little lane and felt as if I were on a deserted island, far, far away. But now that much of the land is full of houses it has lost a great deal of its charm. I never met Mr. Seabrook, but the Seabrook family is fortunate to retain a good deal of the property. Parts of the development are large marshy areas that still wear a wild look. Areas closest to the river offer fine views. Residents enjoy winding streets and good breezes. When the area was being developed a decade or so ago, I'd wander through the tract and dream of what it must have been like a century before, when Yankee troops were stationed there. During construction, many bodies were unearthed and artifacts were recovered. It was an archaeologist's dream.

Today this prime residential area has hefty prices. But to those who value history, it's all a little disheartening. If only it could have stayed a private place like it was for so many years, I sigh. But I'm an incurable

romantic, in the same mold as those writers who years ago lamented changes taking place in the Southland. How I yearn for those days, not so many years ago, really—those days before the "second Yankee invasion" brought thousands from the frigid north to soak up the rays of a sunny South. Naturally, they have discovered the coastal areas and seem determined to stay.

I suppose it was inevitable. Sooner or later word was bound to get out about this delightful little beach near a most beautiful city with a mild climate.

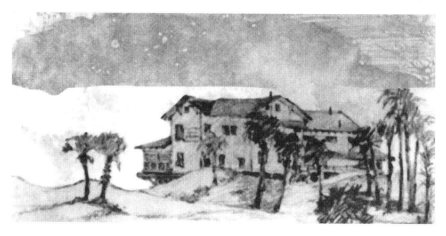

This illustration by Laura Peck shows the Baptist Beach House. *Courtesy of the Post and Courier.*

Baptist Church Beach House Threatened By Eroding Surf

Headline from the late '50s or '60s tells of erosion woes. *Author's collection.*

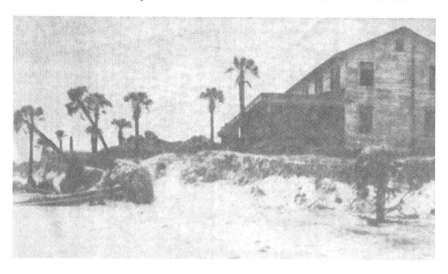

Erosion threatens the Baptist Beach House. Circa late 1950s. *Author's collection.*

The Baptist beach house

For many years it was the last house on the front beach on the west end.

Baptists from throughout the state stayed there. The original frame house was spacious and enjoyed endless vistas. It was destroyed by a fire and rebuilt. This beach house is still enjoyed by church groups today.

Erosion always plagued this section of the beach and the original house was often in danger of rising tides. Recent renourishment has strengthened the beach here. For now, at least.

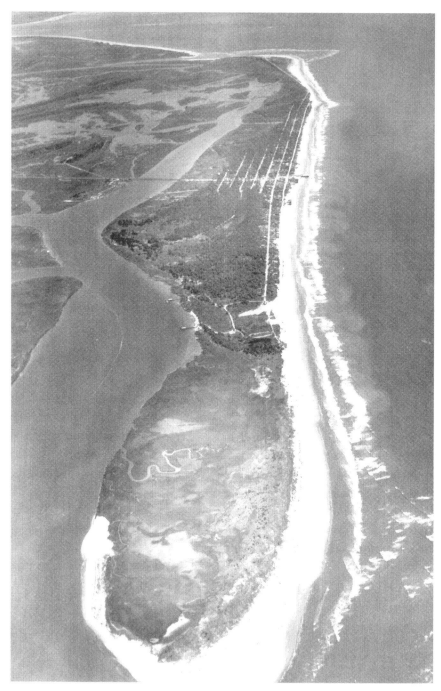

This aerial view shows the west end of the island (in the foreground) with a wide beach. Circa 1950s. *Courtesy of the* Post and Courier.

The west end and beach joys

Like the coast guard base on the east end, a public county park makes up the island's west end counterpart. The section of the beach from the Baptist beach house to the tip of the island, including the park, contains some of the finest scenery around. On one side is the Atlantic. On the other, the marsh and the Folly River. Off in the distance, across the Stono Inlet, lie Kiawah and beyond that Seabrook Island.

One could spend hours walking this stretch and never tire of the views from season to season and year to year. As on the east end, erosion plays a major role here. One year you walk on a wide beach with mighty dunes. Come back a year later and there may be little left. The ceaseless coming and going of the sand is amazing. You certainly can appreciate the power of nature and ponder her fickle ways.

Old pictures show giant dunes lining the beach in the 1940s and '50s. What a magnificent stretch of beach it once was. It may one day return. I remember seeing a picture in a *National Geographic* of a girl and her dog standing on a dune in this spot. The dune looked as tall as a small mountain. Some of the tallest dunes on the island could be found here.

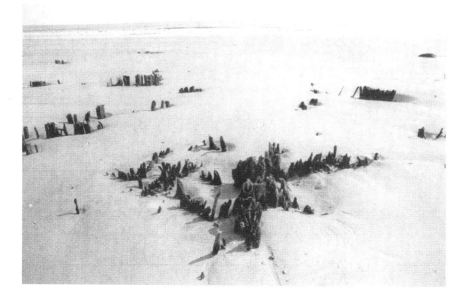

Erosion exposes remains of trees on the beach. *Courtesy of the* Post and Courier.

The power of the ocean is one of the most compelling images as you stroll along the beach. Nowhere is it more evident than at either end of the island. Here, powerful inlet currents swirl around the island, gnawing at the shoreline. These areas are the most dangerous spots to swim. Unfortunately, those unfamiliar with beaches in general often fail to heed warnings posted at the county park and at the former coast guard base.

Years ago there were no warnings that I recall. Most people blithely entered the ocean at will, anticipating fun and frolic in the surf. After all, that was the whole purpose of a day at the beach—to have a good time, to relax and unwind. Unfortunately, the ocean has a dark side and often claims those who let their guard down. Countless drownings have occurred in these dangerous waters. Wise vacationers enter the water soberly.

These more isolated parts of the island offer the best spots to find shells and driftwood. Because of erosion, many trees are toppled, left stranded on the shore. As you walk along these far reaches of the island you often encounter bleached remains of trees and shrubs. Often a palmetto will list precariously toward the sea, exposing its stubby, short roots. Cedars, lying on the shore as sand and sea swirl

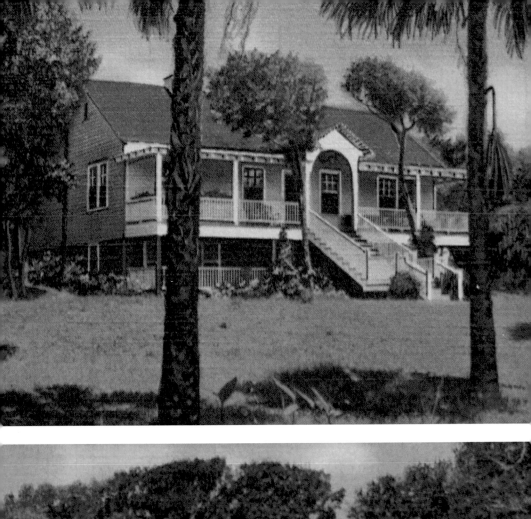

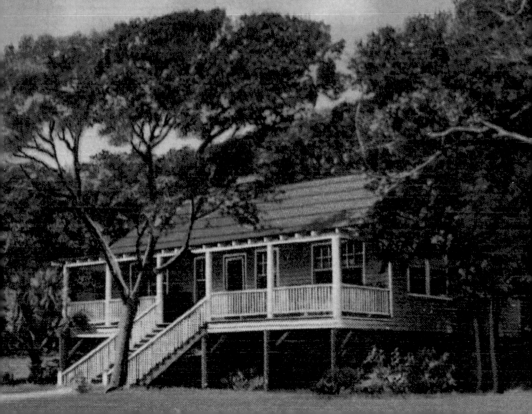

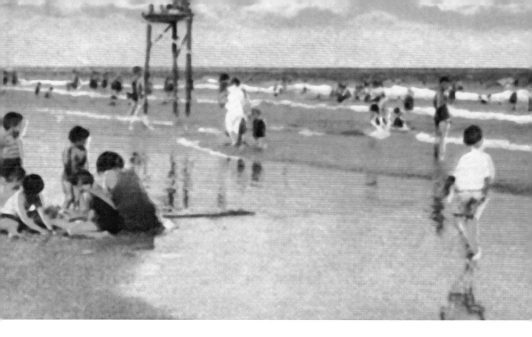

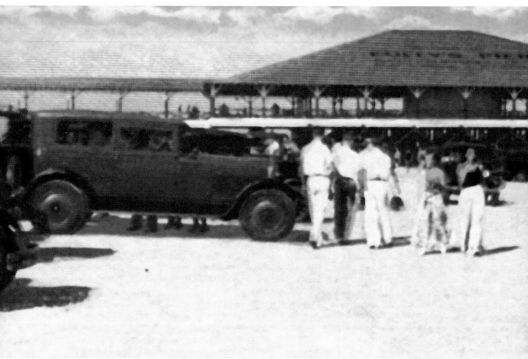

1. *Previous page*: Early homes at Folly were quite attractive. *Author's collection.*

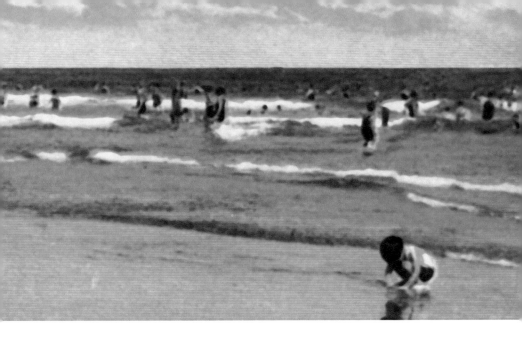

Above and opposite: Old postcards show beachgoers and Folly's Pier with a red roof at ⌐ tide. *Author's collection.*

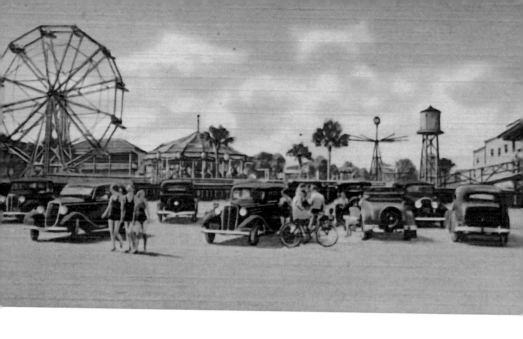

3. Folly's playground and cars on the beach. *Author's collection.*

4. This aerial view shows the pavilion at left with the carnival at center and the pier a right. *Author's collection.*

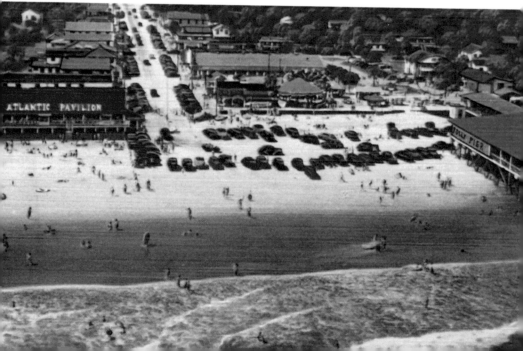

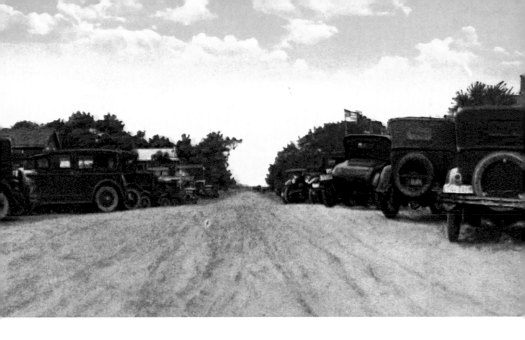

Center street was unpaved in this old postcard. *Author's collection.*

Aerial view shows cluster of attractions on the heavily-wooded island. *Author's collection.*

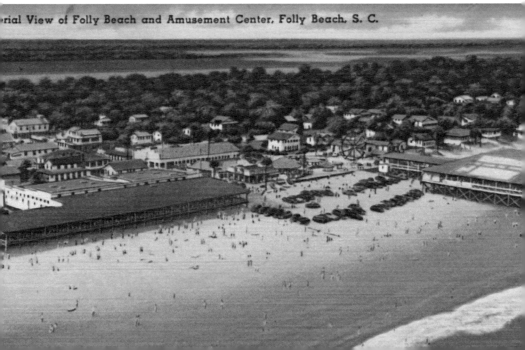

rial View of Folly Beach and Amusement Center, Folly Beach, S. C.

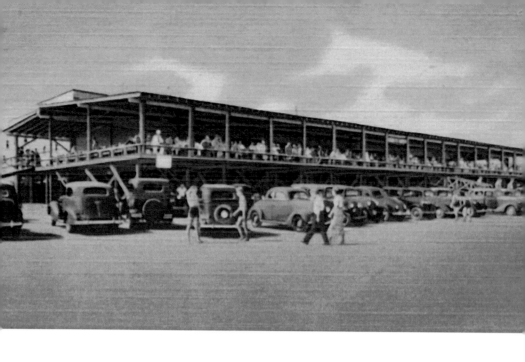

7. The Atlantic Pavilion was long and spacious. *Author's collection.*

8. Folly's Pier sports a white roof in this 1940-era postcard. *Author's collection.*

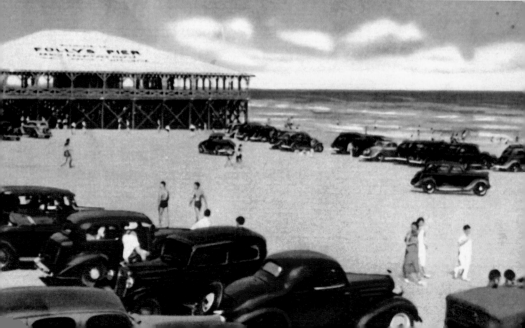

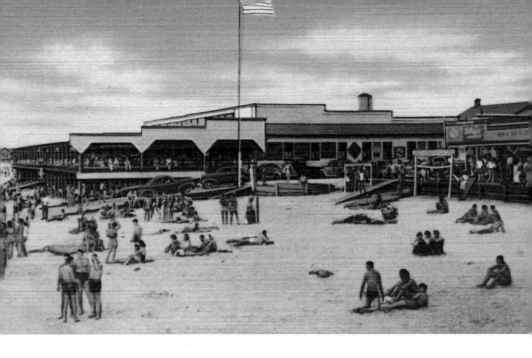

Ramps lead to the beach from Center Street and the boardwalk. The Atlantic Pavilion in the background. *Author's collection.*

America's finest bands performed at Folly's Pier over the years. *Author's collection.*

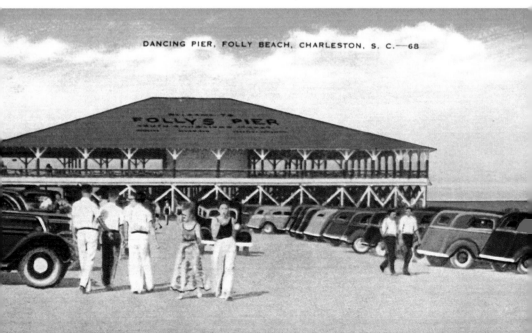

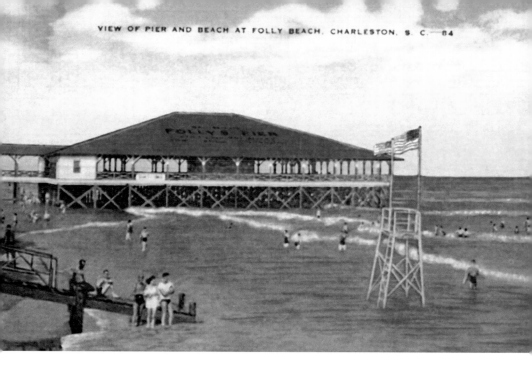

11. High tide with waves rolling ashore under Folly's Pier and washing under wooden ramps on the beach. *Author's collection.*

12. Postcard view shows Ocean Front Hotel (far left), the rebuilt pavilion and the pier with a green roof in the background. Circa 1958. *Author's collection.*

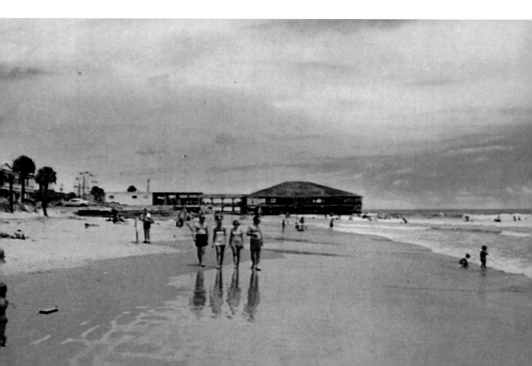

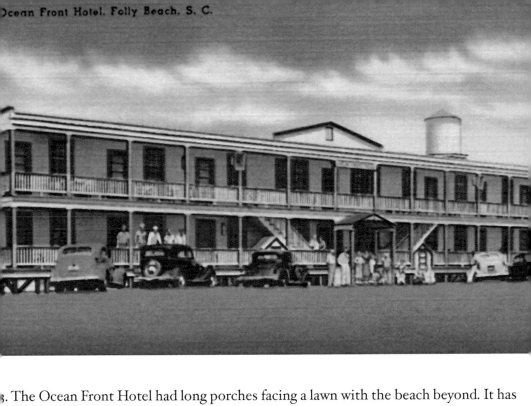

3. The Ocean Front Hotel had long porches facing a lawn with the beach beyond. It has ˍnce been demolished. *Author's collection.*

4. A postcard shows many of Folly's attractions. *Author's collection.*

15. The little carnival all aglow on a moonlit night. *Author's collection.*

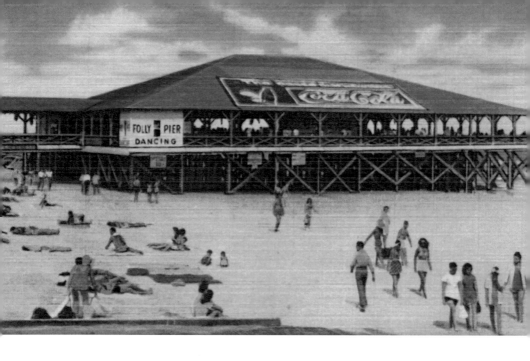

16. Folly pier sports a green roof and a Coca Cola sign in the 1940s. *Author's collection.*

17. Ocean Grill on Center Street. The message written by the sender on the reverse of this old postcard says: "The water is swell, the sand is awful and our appetites are tremendous! More fun." *Author's collection.*

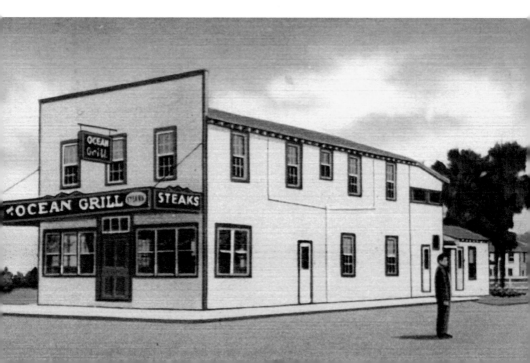

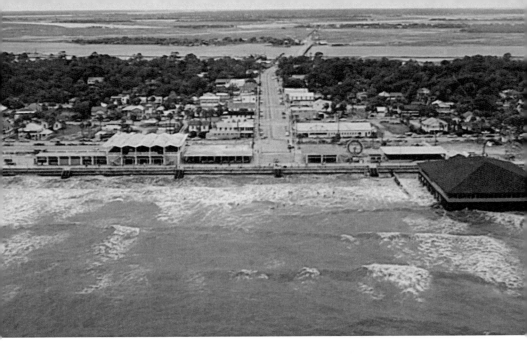

8. Another old postcard shows high tide inundating the beach in front of the new Ocean Plaza development in 1960. The new pavilion and arcade can be seen at left, with a renovated pier. *Author's collection.*

9. Center Street in the 1950s was rather unattractive but enjoyed good sea breezes and views of the ocean. *Author's collection.*

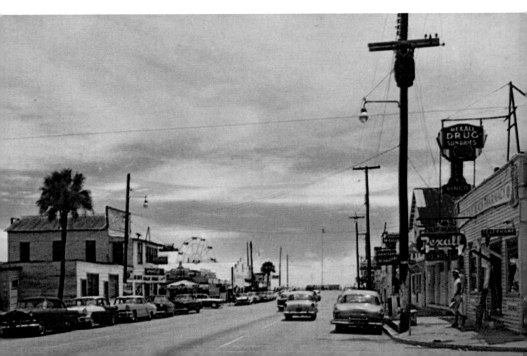

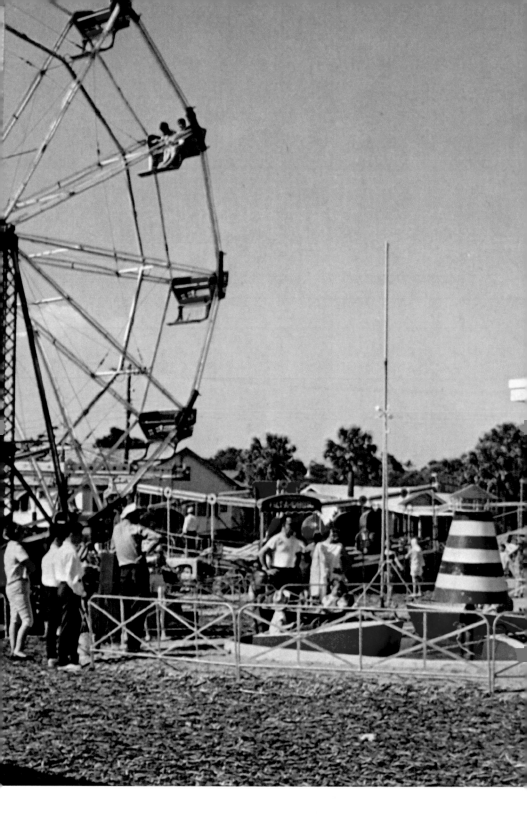

20. The Ferris wheel was a popular attraction at the Folly carnival. *Author's collection*.

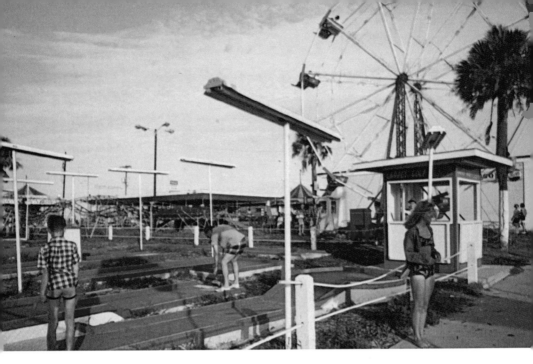

1. The amusement park in later years after Ocean Plaza was developed. *Author's collection.*

2. Ocean Plaza's modernistic buildings, cement boardwalk and revamped pier replaced he old wooden pavilion and boardwalk. *Author's collection.*

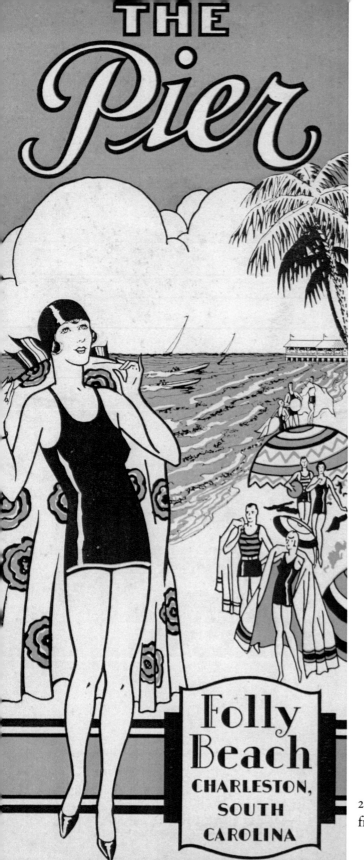

23. A promotional brochure from 1930s. *Author's collection*

around them at high tide, often weather to a soft grey patina. They lie exposed and naked as the tide ebbs.

Gullies are another feature of the beach terrain. As a child, I enjoyed lolling in gullies more than practically anything else. As the tides retreat, gullies appear. After a few hours, with the tide out, the gullies become as warm as bath water. They are the ideal places to put small babies, introducing them to the joys of saltwater. Old folks find gullies irresistible, too. You just lie there and splash around. My paternal grandmother never could get enough of gullies. Her favorites were along Pawley's Island.

One of the surprising delights of a day at the beach is never quite knowing what to expect. The day may be calm, with no wind, hot, stuffy and downright miserable. Just wait. Within a few hours, as the tide comes in, the wind picks up. Waves get higher and the humidity seems to lessen.

Often at low tide, if the wind is stiffly blowing from the southwest, the sand sweeps rapidly down the beach, stinging your legs as you head toward the sea. Times like these make sun bathing downright miserable. If you're having thoughts of a picnic, forget it. You'll be eating nothing but grit.

The lesson of life on the shore is to be patient. Wait out the bad times. Go back to your cottage and take a nap or read a book or jump in the hammock. Or grab a drink. Or eat—my favorite pastime then as now. Just enjoy life in all its many manifestations.

To fully fit in with island life, the best advice is to slow down, go with the flow. Don't try to cram too much into your day. Doing nothing at all is probably the best advice. As you shed your clothes and get into your swimsuit and head to the beach, forget about all your cares. Let your mind wander. For God's sake don't take a book down to the beach. Confine reading to the front porch.

Take only a towel, sunglasses and enough to eat and drink. And flip flops or docksiders. You don't want to scorch your feet on sands that can get fiery hot at midday. In fact, most beachgoers pick the worst possible times to hit the beach. The middle of the day is undesirable, but that's when everyone arrives to soak for hours under a blazing, relentless sun. The ocean is hot. The glare is impossible. To those with fair skin, it is pure torture—even dangerous from a medical standpoint. But that's when everyone hits the beach.

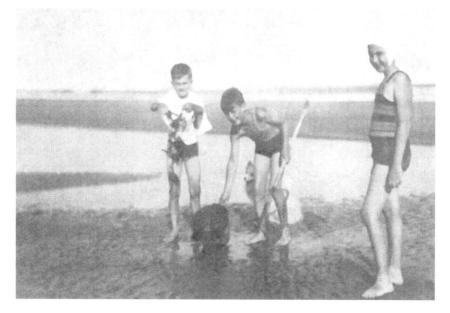

An old brochure from the 1930s promoting the pier and the beach pictured these folks crabbing. *Author's collection.*

The lines of cars on the causeway get longer and longer as noon approaches. Everyone's heading for the beach. By four o'clock, they all prepare to go back to town. If these beachgoers only knew that the beach is at its best either before noon or after four. Doctors for years have advised avoiding the sun between ten o'clock and four o'clock. But that's half a day wasted, you say.

Not so. Repress the urge to hit the beach at high noon. Instead, sleep late, eat a leisurely meal. Read a book then eat some more. Take a nap. By then, you're refreshed. The worst heat of the day may still be at hand, but the glare is less fierce. The winds have kicked up. Most of the huddled masses have left. (Except for those hardy souls—mostly young adults—with unlimited energy, who can play ball, throw frisbees, drink quantities and still surf.)

If you're either a young kid or among the older folk, you will reap innumerable benefits by goofing off in the cottage most of the day. Relax. Like I said, essentially, do nothing. Wait. Later in the day you'll feel invigorated and ready for two or three solid hours of pure joy. Jump in the ocean and ride the waves to shore. Flop around in the

gully. Look for shells. Go for a long walk. Toss a frisbee. Play half rubber. Take a nap on a towel than take another dip. Have another drink. Eat watermelon. The list is endless.

But if you really want to appreciate the beach during these delightful hours, I'd suggest you sit upright in a folding chair and just look around. There's much to see. Every facet of humanity will come into view, despite the fact that the throngs have mostly left. Enough people will have stayed to give you company. You'll see shapely women; portly, hairy men and precious children. You'll see people playing horseshoes, flying kites; people jogging, others strolling along; lovers kissing and snuggling on towels. You'll see humanity. All this on one of the most delightful spots on earth: the beach.

The beach is also an ideal spot for talking. If you're with friends, you can be frank. Something about the lazy, hazy days and the salt air will take away much of the bite out of what you have to say. Most people of all walks of life happily commingle at the beach. It's no place to argue.

One of the most appealing things about the beach is the conviviality it engenders. All types of people, mostly almost naked, having fun on the sand and in the sea—what's wrong with that? I've often thought most of the world's problems could be solved by spending a week at the beach. Just chill, as the youngsters say today. Good advice.

At mid-century, America was on top of the world. The dark days of war were over. Everyone was optimistic. As a child growing up during this time, I experienced the general feeling of contentment that was felt from shore to shore. This feeling was magnified by going to the beach. Nothing, to my way of thinking, was more wonderful than time spent on the beach.

Folly in those days was all about fun. Everywhere you went, up and down Center Street, strolling along the interior streets or sitting at one of the refreshment stands, you felt happy. But I was just a young boy and that's how young boys should feel, you say. Yes, but what I remember most vividly is that everyone—young and old alike—seemed to have a good time at the beach. You left your worries—if you had any—at home. No sulking, no sad faces at the beach. Only laughter—and lots of it.

Trigger Burke
and other crooks

I'd be remiss if I didn't include something about the famous criminal—one of the FBI's ten most wanted—known as Trigger Burke.

For a time he lived at Folly and was captured there in a rather spectacular manner right in the heart of town. In those days, Folly was still a township, not the city it is today. (For some reason I still don't think of Folly as a city—just an island.)

I don't want to dwell on this criminal or any of the other unsavory characters who occasionally showed up at Folly over the years. And there were quite a few bums who lived there, and still do. No, my main point in these rambling ruminations is to convey the utter happiness I and countless others got from time spent at Folly.

No need to dwell on Folly's dark side. (And there was always a sinister undercurrent, like everywhere else. This was no Eden by a long shot.) But as a young boy, I knew nothing about that. Sure, I saw the drunken sailors passed out under the pavilion. I saw tipsy women come out of dark bars. I saw things children see in nightmares—scary things like people arguing and fighting.

Frank Gilbreth, the late local newspaper columnist, once wrote a poem about Trigger Burke. Gilbreth was also a reporter who interviewed Gershwin at Folly in 1934. He remarked about Gershwin's quick acclimation to island life, accustomed as he was to Manhattan luxury. His Folly accommodations were a far cry from his New York digs.

I suppose you're wondering just what Burke's crime was. According to Gilbreth, Burke, whose real first name was Elmer, was wanted for "murder in New York, for the ambush-shooting in Boston of a Brinks robbery suspect and for a sensational Boston jailbreak."

Charleston beaches long have been a haven
For lovers and tourists and the poet who wrote "The Raven."
But the shootingest tourist with the meanest quirk
Was a New York gunman named Trigger Burke

Trigger had a buddy and shot him dead,
Used a pistol to fill him full of lead
Trigger had another buddy, shady as a spook
Name of Connelly, alias the Duke.

Duke and Trigger preyed upon the yanks,
Took their gold and silver and never gave them thanks.
When the cops put out their big alarms,
Trigger brought Duke to the Isle of Palms.

"Don't fret, buddy," Trigger said to Duke,
"Only time they caught me, it was only a fluke.
Don't fret, buddy," he repeated with a smirk,
"There ain't no jail can hold Mr. Trigger Burke."

Duke must have felt he was in the middle.
What happened to Duke is still a riddle.
But Trigger was afraid the Duke would peach,
So Trigger moved over to Folly Beach.

Lived all alone, in a cement house,
Minded his manners and was quiet as a mouse.
And all the time he was grinning like a pixie,
"Ain't the cops dumb Down South in Dixie?"

"Ain't the cops dumb? And ain't they hicks?
Safest place to be is here in the sticks.
Southern coppers? — Well, by golly,
They'll never dream that I'm hidin' out at Folly."

But the cops weren't dumb and that's no lie.
'Cause the cops and the sheriff and the FBI
Crept down to Folly, there to lurk.
And trapped like a rat Mr. Trigger Burke.

"Put up your hands," said the FBI.
"Face the wall, Trigger, 'less you want to die.
Burke, you've been acting mighty regal.
Now lie down, Trigger and do the spread eagle!"

Trigger done just like he was told,
Lay down like he was knocked out cold.
But all the time, only one thought lingered.
"I wonder," he grated, "who had me fingered."

"Trigger," said the cops, "it's sad to tell,
We got to take you now to Seabreeze Hotel."
He heard those words and Burke turned pale.
'Cause the Seabreeze Hotel is the county jail.

There's not much more of the story to report.
The cops brought Trig to the Charleston Court.
When reporters took his picture, he didn't say "thank ye."
Covered his face with a spotless hankie.

Burke told the judge with a mealy mouth,
"Please, yurhonor, can I stay in the South?"
The judge replied with nary a snigger,
"You'll like it up North, Mr. Convict Trigger."

They put Mr. Burke on the train "Champeen,"
And he said with a sneer that was almost obscene.
"What happened to me shouldn't happen to a collie,
When the Southern cops found me hidin' out on Folly."

Hurricanes

Living along the coast during those decades was indeed hazardous to your health. It seems as if Folly was forever being battered.

This little recollection starts with the brutal storm (unnamed in those days) of August 1940. I was not yet born, so I must rely on tales of older folks and residents who lived on Folly back then. Newspaper accounts were dramatic. They told of tidal surges and destroyed buildings and huge financial losses. Owners of the pavilion said it was the end of Folly.

They couldn't have been more mistaken. Folly bounced back, but only to be struck time and again. The next major storm, Hurricane Gracie, came along in September 1959. I remember that gal well. I was thirteen at the time, and living in the city, in Hampton Park Terrace. As the storm buffeted my neighborhood, I thought it was the most exciting day of my life.

During a lull in the storm, I went to a neighbor's house to visit. He was a Charleston lawyer and owner of a summer home on the Isle of Palms. He seemed worried as he looked outside at the limbs of a giant oak tree, torn loose and spread upon the sidewalk. He feared the tree was doomed. It survived.

Vast Wreckage at Folly; Over 50 Houses Destroyed

Headline from August 13, 1940, describes damage from storm of August 1940. *Author's collection.*

Folly And Edisto Islands Blasted By 125 MPH Winds

Grim Gracie Played No Favorites And Lashed Out In All Directions

Folly Beach Is Damaged Severely

Headlines from September 30, 1959, tell of Hurricane Gracie's blow in September 1959. *Author's collection.*

After awhile I returned home to my grandmother. My aunt and uncle were in New York to watch The Citadel play West Point in a driving rain as the storm headed up the coast. Another neighbor brought over a turkey to roast in our oven. We were lucky—we had an old Magic Chef gas stove. Her stove was electric. (I wish today I still had a gas stove during hurricane season.)

In those days the only ones who evacuated were folks on barrier islands. Those living in town or the suburbs stayed put. I don't recall the hysteria that now emanates from television announcers weeks before the storm even gets here, if it comes at all. It strikes me that the old-timers had a lot more sense and didn't get as rattled as people today. If the storm came, so what. Make repairs, rebuild or forget about it.

Apparently, many Folly Islanders took the latter option. After the 1940 blow, the remains of the shacks stayed on the beach for years. As I mentioned earlier, the cottage Gershwin rented (owned back then by a Mr. Tamsberg) was lost to the storm.

After that hurricane, what was once the second row of houses became the front beach on the west end. It remains so to this day. Atlantic Avenue returned to its namesake. I understand the lost row of houses extended eight blocks or so along the west end. As you walk along this stretch of beach today, it's hard to believe you're actually walking where houses once stood; where people ate and slept and lived for several decades. It all vanished in a day. Such is the power of the Atlantic. Don't ever underestimate her might.

I suppose all those cottages couldn't have been rebuilt, for the beach never recovered and the tide inundated the foundations. Over time, most remnants of those houses eventually were removed or perhaps decayed and covered by sand. They were still there, though, in 1946, when I was an infant and sat on the beach in front of a friend's old house (owned by the Farrow family at the time). I'd like to know when the remains finally disappeared. For years when I looked at those old family photos I thought I was looking at parts of groins on the beach. But groins weren't constructed until some years after the pictures were taken.

I recently learned that these posts poking out of the sand at low tide were parts of revetments in front of the old houses. I talked about storms to many of the folks who were living at Folly in 1940. One such individual, the artist Sally Aimar whom I've mentioned

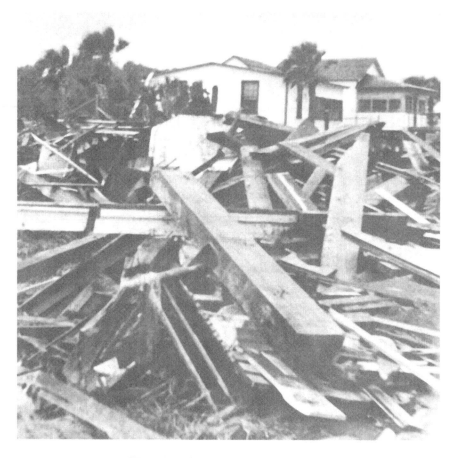

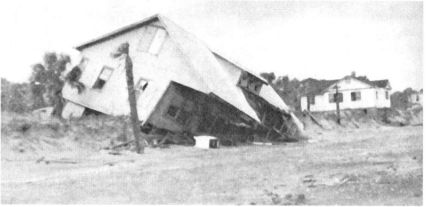

The hurricane of 1940 washed timbers of demolished houses throughout the island and toppled houses onto the beach. *Photo by Edwin H. Stone. Author's collection.*

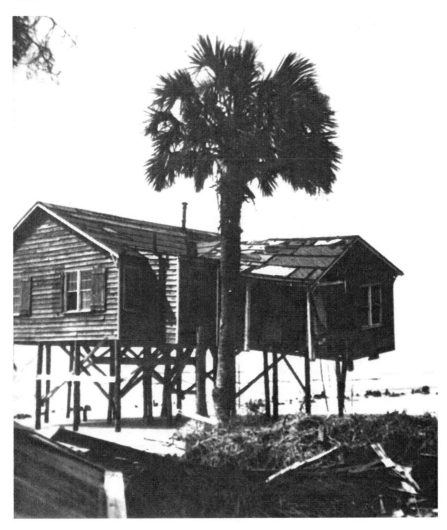

This old cottage that stood near the Atlantic House survived the 1940 blow.
Photo by Edwin H. Stone. Author's collection.

previously, recalled that storm and another a few years earlier that
had been particularly destructive to New England.

Sally said her mother's house was down the east end, before the
Washout. Sally and her husband, Harold, left the beach and headed
for the hills. (In this case, the mountains of North Carolina, a favorite
spot for Charlestonians to vacation during August heat waves.) When
Sally returned, there was nothing left of her house. She recalled

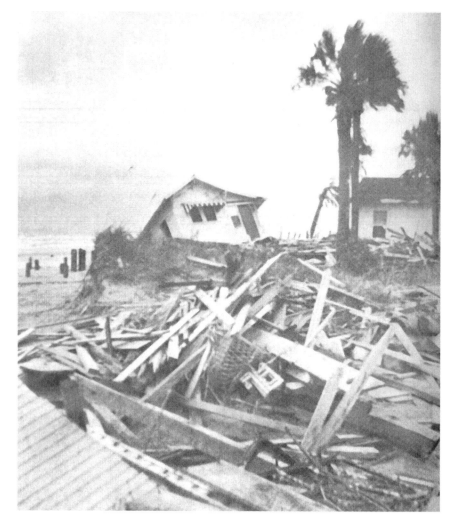

More extensive damage caused by the 1940 storm. *Photo by Edwin H. Stone. Author's collection.*

seeing a spoon sticking out of the sand where the house had stood. This particular stretch of beach never came back either.

In 1959, Gracie again devastated large parts of the island, wrecking many of the picturesque old cottages. But of course, Folly recovered from Gracie, too. It is lucky that Gracie struck at dead low tide, blasting Edisto Island with full force. If it had hit at high tide, poor little Folly would have been smashed. And smashed is how some Folly residents

survived storms. Some individuals—idiots all—decide to ride out storms on the island, throwing "hurricane parties" and challenging the winds. One couple, who stayed during 1989's Hurricane Hugo, told me afterward that they had never been so traumatized. Never again, they vowed, as they sipped their brews with trembling hands.

Folly again recovered from David in 1979, which did some damage to the Washout area. Folly also survived the granddaddy of all Southern storms, Hugo. It took but a few months for the insurance money to pour in and all the little shacks were replaced, this time with vinyl-clad monstrosities. While in years past damaged cottages were patched up and maybe repainted that blue-grey stain I so admire, now the houses were just bulldozed away. How sad.

Undoubtedly, there will be many more storms in Folly's future. One old-timer told me once that there is probably a storm lurking out there that will forever doom Folly, rendering it little more than a sandbar out in the sea. But I wouldn't bet on it. Given Folly's tenacity and fighting spirit, I'd bet there's nothing out there that she can't handle.

But to get back to those mysterious remains that I can't seem to forget...

After Hugo, I took a detailed tour of Folly on foot and by car. I climbed over wrecked houses; I sawed up branches in my own island backyard (only to get a fierce case of poison ivy on one arm). While investigating the west end, damned if I didn't come across posts sticking in the sand. Could they be those in the 1946 photos? What survived, covered with barnacles, appeared to be in the right spot. Did Hugo's waters unearth them? I was as delighted to find them as any Egyptologist. But I still don't know exactly what they were. Maybe they were just tree stumps. That's what's so entrancing about beachcombing. You never know what you'll stumble across. I've seen washed-up giant turtles, horseshoe crabs, huge seashells and other mysteries of the deep. Some beachgoers haven't been so fortunate. More than a few have found bodies—drowning victims. But that's another story.

Speaking of beachcombers, I've always liked the word, with its carefree associations of endless treks along the shore, stumbling upon treasure to take home and enjoy for years. There was a club called the Beachcomber on the way to Folly back in the 1940s, but it was gone before my time. I remember as a boy passing the remains of the old joint, just off Folly Road.

In the 1950s, when Folly Road was a two-lane highway, the road curved around some old docks, enjoyed by black fishermen in the area. There was a sweet shop or two nearby and perhaps a tackle shop. The Beachcomber was just off the road sitting in a weed-filled field on the edge of the marsh. It looked forlorn sitting by the side of the road. It probably was one of the wild spots that so many beachgoers enjoyed during those carefree years. No traces remain today.

As I mentioned earlier, there was a place called Geezer's farther along Folly Road, next to a bridge. I don't know what fate befell that joint, but it was among the constellation of popular dives that beachgoers of yore patronized. Maybe Hugo was the culprit. It was a rough spot, with a motley crowd (as all good beach bars should be).

Hurricanes destroyed many such landmarks. Unfortunately, what took their places were perhaps not what you wanted. But we still have memories.

Rainy days at the beach

What family doesn't dread a rainy day at the beach, especially if the rented cottage (or motel room) is full of hyper kids? I recall quite a few rainy spells at Folly, but they were usually brief. One such storm occurred late in the afternoon and lasted through the night. By daybreak the sun came out and all was fine from then on.

But suppose the rain lasted all day and night and the next day.

Back then I think most Folly cottages rented for less than a hundred bucks a week—easily a week's pay. There weren't any refunds. What did you do? Fortunately, there were usually breaks in the rain, often occurring late in the day. The sun suddenly would pop out, often with a rainbow appearing. You'd make the most of this special time. The sea likely would be calm and the air was cooler. Walks along the beach now would be worthwhile. By late night the rain returned and lasted through the day. If your cottage had a tin roof and a screen porch, you'd be in heaven. Rain on the roof sounded like a symphony.

Rainy days were ideal times to read. Children could play games or, if the rain was light, explore the beach. Beachcombing in the rain can be rewarding. You've got no company, except perhaps other fools walking in the mist. In winter, foggy days were equally as special. A

walk along the shore took on an unexpected look. You could see little, but could hear the ocean. By the way, the ocean's roar can be heard all across the island at certain times during the winter. If you're on the backside of the island, the sound can be as loud as if you were on the shore. Sound travels differently at these times.

But the beach and sun are synonymous. Spending a week at the beach in the rain really is a drag. It doesn't happen that frequently; often the city or James Island will get rain and Folly will stay bone dry. Frequently stiff ocean breezes will push the storms away.

If you happen to be in town and it's raining and all seems gloomy, head out to Folly anyway. In all likelihood, by the time you arrive the sun will be shining, the wind will be blowing and you'll have a great time.

Odds and ends

There were so many facets to Folly. I've mentioned most of the main points but there are some loose ends that need tying up. I've talked a lot about erosion. Often homeowners put bulkheads in front of their front yards almost up to the high tide mark. These bulkheads held up much of the time, only to be demolished by storms, then to be rebuilt.

Unfortunately, these ramparts didn't allow the beach in front to build up. They blocked the flow of sand. Often sand would accumulate, but more often it would just blow over the top, through the yards, and into the street. (Sand still accumulates on the street today at many parts of the island, especially near where the Atlantic House stood, as well as at the Washout.)

Studies of erosion were completed during the 1930s, but nothing was done until a decade later. In 1948, the first groins were placed along the beach. Old photos show that sand accumulated, especially many blocks down the east side, near where houses were washed away in 1940. This part of the beach has, through the years, held up remarkably well. Farther down, at the Washout and beyond, sand comes and goes—mostly goes. (A major renourishment project in

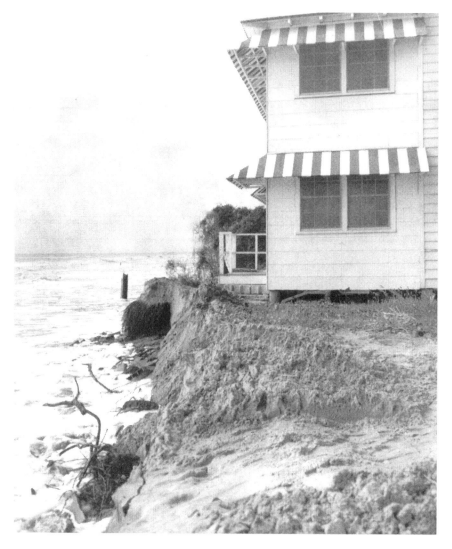

Erosion threatens a Folly cottage. Circa 1950s. *Courtesy of the* Post and Courier.

1993 provided a broad strand along much of the beach. But the sand didn't hold up at the Washout, nor a few other spots, notably west of the Holiday Inn.) Renourishment is in the works again.

Looking at old newspaper clippings from the 1950s, I'm struck by the number of references to erosion and the need for more and more groins. The first groins were wooden and eventually decayed. Those were

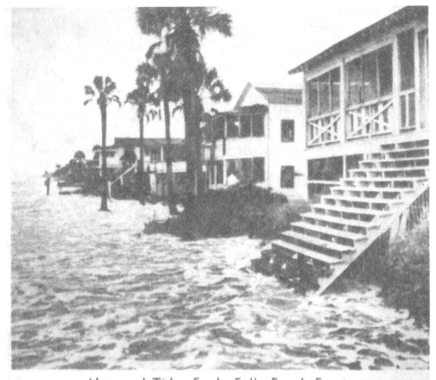

Abnormal Tides Erode Folly Beach Front

High tides, which ran as much as 16 feet above and destroyed several bulkheads on the Island, normal, sent salt water lapping at the foot of The high tides, caused by northeasterly winds, these houses on the west end of Folly Island are expected to hit near record levels for the The tides reportedly undermined some residences year again today. (Staff Photo by Gibbs)

This newspaper photo shows erosion at Folly in August 1957. *Author's collection.*

replaced by more substantial revetments of concrete and metal, from the pier for miles along the east end. They have worked well, by and large.

Exposed old groins extend along the west end. They're often covered with sand. When exposed, they're just a few jagged posts. Rocks were added to bolster the groins. Sometimes the groins work. More often they don't. It all has to do with ocean currents and shifting sands. Northeast winds do much damage through the winter. It's a constant battle.

What seem to work best in the battle are sand dunes, sea oats and sand fences. Dunes build up over time on a healthy beach, if not eaten away by storms. Sea oats and other vegetation anchor the dunes and encourage more sand to accumulate. Sand fences work well after

Sea oats and sand dunes help fight the battle against erosion. *Courtesy of the* Post and Courier.

renourishment. Of course, all this is temporary, as beachgoers know. Nothing really can stop the Atlantic! It's a losing proposition. But the tide can be held back for a while.

Today it's against the law to cut sea oats. You also can't walk on the dunes, hence, all those walkovers along the beach. But during the 1950s everyone plucked sea oats all the time. They were attractive decorations in most cottages. And they lasted forever! I miss seeing them in the house, but they do serve a purpose on the dunes. The sea oats bloom in late summer and look particularly attractive as they rattle in the breezes. They also have a fresh, beachy smell.

Speaking of beachy things, I especially longed for the beach after I returned to my home in town. I wanted a part of Folly in my backyard. Fool that I was at ten years old, I tried, with hammer, nails and lumber (and a vivid imagination) to recreate the look of Folly. I made a makeshift sign, painted it green and wrote "Folly Pier" using white paint. I imagined the high hedge at the back of the yard was a giant wave. I'd put on my swim trunks and lie on a blanket, grab some Kool-Aid and hit the backyard and dream of the beach. The small pool was the ocean. Often I'd get my aunt to cook up some french fries to complete the deception. One of the neighboring children would join me in the pool. If I was lucky, the cute little girl down the street would join me on the blanket for a soak in the sun. A vivid imagination can work wonders. I wish I'd taken pictures of the ridiculous scene. (Maybe it's a good thing I didn't!)

Among other things that grabbed my attention about Folly were all the houses that washed away. I've always been nuts about cottages, and at one time I wanted to be an architect (but detested math, so thoughts of being an architect were abandoned). My great aunt once had a small cottage on the east end of Folly, so I was told. I never saw any pictures of the little place and never heard what happened to the house or when it disappeared. But I think it could have been among that group of houses that washed away in 1940. It was just one of countless houses lost to the sea over the years.

It seems to me pointless to build a mansion on a barrier island, especially one as volatile as Folly. Little shacks make more sense. Back then, with beach lots relatively inexpensive, people didn't sink much money into beach houses. Old-timers had much more sense than most people today. Of course, if you pay a million bucks for a front beach lot, you're not going to put up a shack. In fact, zoning today prevents it. But why build a mansion when a smaller home would work as well?

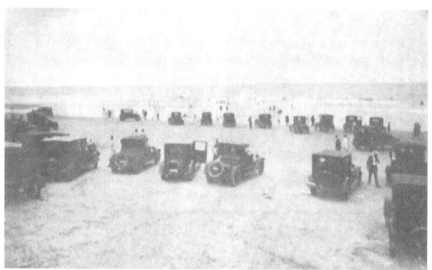

Cars parked on the beach in the glory days. *Author's collection.*

The whole point of living at the beach, as I've said time and again, is to relax. Who really can relax in a mansion? Beaches and cottages just naturally go together. Air-conditioned houses on the front beach also seem peculiar. What's better than the ocean breezes? In those carefree years of my youth, people escaped the heat of the city and headed for the shore to cool off. A former colleague of mine at the *Post and Courier* (the *News and Courier* back then) told me that back in the 1940s late-night workers left the newsroom and headed to Folly to swim and to catch the breezes.

I keep stressing how simple life was back then. You weren't told not to go in the sun, don't park here, don't walk on the dunes, don't pick the sea oats, don't walk your dog on the beach. Don't do this, don't do that—rules are everywhere today. Before long there will be a sign saying "Do not crush the seashells. Subject to fines." These politically correct times often seem absurd to me.

During World War II, Charleston's navy yard was in full swing. Housing was scarce. Many of these shipyard workers stayed at Folly. Men were crammed into many small cottages where the rent was cheap. What could be more fun in the summer than to live at the beach where all the beer, sand, sea and girls were? Many of these workers found their wives at Folly.

Other than the artists and writers who called Folly home (at least part of the year) there were many colorful year-round residents. Tom and Kitty Wienges ran the newsstand at the corner of Center Street and East Hudson. This was the place to go to grab your paper or a popular magazine and hang out with all the locals—a community gathering spot. You could grab a good bowl of soup here and catch all the gossip. (And there always was something to talk about!) Wienges was a real estate agent and handled many of the rentals in those days. I remember listening to his stories about colorful events. He knew everything there was to know about Folly. He and Kitty are gone now, as is their little newsstand. It's one of the few lots left vacant on Center Street.

Like Wienges, Paul and Carolyn Shelton were a wealth of information about anything about Folly—and anything else for that matter. They were intelligent and optimistic and always saw the good side of living at Folly. They, too, appreciated island life when Folly was young and wild. Paul could tell you tales that would leave you rolling on the floor with laughter. He was also somewhat of an authority on beach ecology and had good ideas about rebuilding the beach. Carolyn especially was fond of all the trees that provided Folly with cooling shade. They're both gone now.

My next-door neighbor when I lived at the beach was Lois Hume. She moved to Folly when she married in the late 1950s. Lois recalled endless swims at the beach when she was young. She grew up on nearby Johns Island and lived on the river (or rather in the river). She loved the water. She loved Folly, too. But she didn't share Carolyn Shelton's love of trees. She'd cuss me out for the tall pines in my yard. She detested all the oak leaves that fell in her yard and she positively hated the large magnolia leaves that fell every May just when the giant blossoms appeared. Lois raised pure hell with me after Hugo. She said my trees fell into her yard, causing much damage. But I pled innocent. Blame God for that, I told her. Lois died many years ago.

Farther down the street from me was an elderly couple. When Mr. Keith died a few years back he was in his nineties. Keith was a boxer in his youth. Folly used to have boxing matches (and drag races) on the front beach. He was a small man but tough. He helped out all the widows on the beach who needed most any type of home repair. He was often over at Lois's house fixing this or that. Keith (I can't recall his first name, but his late wife was Evelyn) knew all the old-timers at

the beach and also most of the old folks in Charleston. I even found out that he once lived down the street from a house I owned in later years in town on Queen Street. Small world.

Folly was indeed full of interesting people, people who took an interest in others and wanted the beach to be a good place to raise families. Most were hard-working individuals with a strong patriotism and a colorful, happy spirit. We could use more of these types today.

In closing

Much has been written about Folly over the years. Files at the *Post and Courier* bulge with articles going back to its founding. There are stories of endless storms, countless drownings, pie-in-the-sky development proposals, erosion, murders, hooligans and other such things. A veritable treasure trove of information about a beach barely half a mile wide and only six miles long!

What accounts for Folly's ability to make the news? It often made front-page, banner headlines!

When storms head this way, reporters today flock to Folly, knowing that that's where, in all likelihood, the big waves will break. Poor Folly—always raked over the coals by Mother Nature. But like a tough bruised little kid, she gets back up, dusts herself off and gets back in the game, only to be knocked around again and again. Will she ever learn to pick her fights? I don't suppose so. It's in her nature to be cantankerous. She likes a good brawl and usually can get in the ring with the best of them and come out a winner.

There were a lot of real fights at Folly in the 1940s and '50s. At one time the navy even considered putting the place off limits to sailors. What else could be expected, with bars all over the place and women

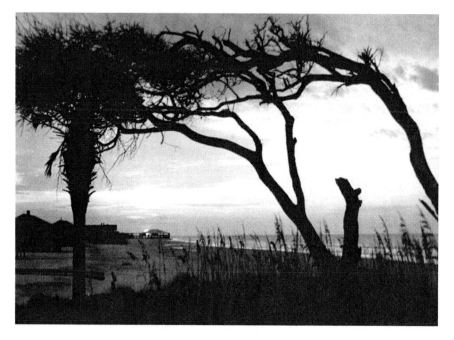

Sunrise at Folly shows the scenic shore with Folly's pier in background. Circa 1930s. *Courtesy of The Charleston Museum.*

lined up along the beach as far as the eye could see? Fashions back then were more modest than today's thong suits, but the photos of the time show some striking, sexy women.

There was something about the way the wind whipped through the palmettos. There was something about the songs on the jukebox. There was something about the waves as they rolled beneath the pier. There was something about the way the sand blew across the shore, about the sound of the screen door slamming shut as children raced in and out the house, laughing on their way to and from the sea. There was something about the way you felt as you walked along the beach and gazed at the tide with a pretty girl by your side.

The first photograph in one of my favorite books—*South Carolina Bird Life,* published in 1949—is Folly Beach by moonlight. It's my favorite picture of the island. It shows a calm ocean. In the foreground are palmettos at the edge of the shore. I don't know for a fact exactly where photographer Russel Maxey snapped that shot. But if I had

to guess it would be near where Gershwin's little cottage stood and washed away in 1940.

Back in the 1950s, I often swam (or tried to) in this area. At high tide, the ocean came right up to the palmettos, swirling around the trees. This part of the island is still heavily wooded. It's my favorite part of the beach. The former home of DuBose Heyward sits in a grove of trees nearby. Down the way is my favorite home of all—that old beach cottage I mentioned a while ago. It has a wide front porch overlooking a row of dunes and sea oats. There is a large vacant lot next to it covered with palmettos. A big oak tree sits behind the house.

This small cottage is depicted by Charleston artists who have uncovered her appeal. They have stumbled upon what I (and many others) considered to be the ultimate image of the island. This one small cottage encapsulates the complete feel of Folly. It's the right size, not too big, not too small. It's painted the ideal shade, imparting a cool, relaxed look. It's in the perfect setting—a grove of palmettos. It was used in a film that was set in the Caribbean. It's the most tropical-looking spot on the beach.

I remember this cottage well. In 1958 I took a picture of my maternal grandmother and aunt sitting in chairs on the beach. In the background is a tall dune, jagged from erosion, a few palmettos and the porch of the cottage. Today there is an enlarged spot, enough room for cars to park. There's a tall walkover that blocks the ocean view. But once I reach the top step and gaze at the beach and sea laid out before me my heart beats faster. I'm home and happy.

From my introduction to Folly on that hot August day in 1946 when I was eight months old until the present, I've been hooked. When my handsome father sat me in that warm gully, my little diaper-clad bottom must have felt relief. The beach does that to you. As Sally Aimar once said, "There's nothing better."

To all those beachgoers who recall the old days at Folly and those tykes who are just introduced to her joys, I say this: have fun, enjoy yourself, be happy, take in the moment and you'll have memories for a lifetime.

To those my age who lament all the changes and look back wistfully to those magic days of yore, I say this: meet me at the beach and let's find a cool spot under the pier. Let's have one for the road.

About the Author

B ill Bryan grew up in Charleston, attended the University of South Carolina and graduated from the Baptist College at Charleston (now Charleston Southern University). He was a reporter and copyeditor at the *News and Courier* (now the *Post and Courier*).

He is interested in preservation of both old houses and neighborhoods and considers himself an environmentalist and dedicated beachcomber. He enjoys collecting books and reading.

Visit us at
www.historypress.net